Hand Lettering Made Easy

John Smith

Mr. and Mrs. Smith
209 Church Street
Nashville, Tennessee 37205

by Debra Beagle

Hand Lettering Made Easy. Copyright © 2004, Debra Beagle. All rights reserved. This book may not be duplicated in any form without written permission from the publisher, except in the form of brief excerpts or quotations for the purposes of review.

First Edition. Printed and bound in the USA

08 07 06 05 04

5 4 3 2 1

Library of Congress PCN: 2003114677

ISBN: 1-930500-13-0

Limit of Liability & Disclaimer. The author and publisher have used their best efforts in preparing this book. The author and publisher make no warranty of any kind, expressed or implied, with regard to the instructions and suggestions contained in this book. The scrapbook page layouts throughout this book are used with permission.

Published by: EFG, Inc.; St. Louis (314) 762-9762

Distributed to the trade by: North Light Books *an imprint of F&W Publications, Inc.*

4700 E. Galbraith Rd. Cincinnati, OH 45236 fax: (513) 531-4082 tel: (800) 289-0963

Lining It Up

Holle placed notebook paper under the vellum so her lettering would be straight.

To:

My husband Bob, who continually encourages and supports me in whatever I do. You are the love of my life.

My two beautiful children Stephanie and Michael; I love you so very much and leave this book as a gift to you.

My grandmother Betty Kimble, for teaching me to create beautiful lettering.

My mom and dad who have always told me anything is possible.

My publisher Elaine Floyd, for believing in this book.

Gigi and Papa, whose love and constant support mean the world to me.

Bonnie Lees, who has been by my side, teaching my lettering classes.

My dear friend and business partner in the Simply Scrapbook & Stamp Convention, Kate Childers.

My dear friend, favorite attorney, scrapbooker and talented artist, Victoria Bowling.

My many dear friends who have contributed to this book: Linda Beagle, Christy Kalbhin, Karen Moffatt, Angie Pedersen, Nancy Walker, Holle Wiktorek, and the stamp club ladies.

The companies that have supported my classes: Steve Harmon, Larry Speakman and Debby Carter at Marvy Uchida; Bev Arrowood at Glue Dots; Pamela Lange at K&Company; ProvoCraft; Vicky and Tom Breslin at Cut-It-Up; David Wilke at Paper Adventures; and Kate Griswold at Michigan Mega Meet.

The craft and scrapbook magazines for their support: Michele Gerbrandt, Michelle Minken and Shawna Rendon at Memory Makers Magazine; Stacy Julian at Simple Scrapbooks Magazine; Creating Keepsakes Magazine; PaperKuts Magazine; Scrap & Stamp Arts Magazine; and Melissa Inman at Better Homes & Gardens Scrapbook Etc. Magazine.

My webmaster Peter Guse for all his hard work on my website.

Margaret Sheppard whose work inspired me to teach calligraphy.

All of you for whom this book is written and who are interested in keeping the art of hand lettering alive.

The Gift of Friendship
by Holle Wiktorek

TITLE ALPHABETS: Holle #2 and Nanci #22

JOURNALING: By hand

PENS: Marvy Medallion, Marvy Memories Artist, Le Plume and Calligraphy.

OTHER SUPPLIES: Paper by All My Memories and DMD. Circle tag by SEI. Wire by JewelCraft. Buttons by Westrim. Eyelets by Creative Impressions. Peel n Stick Zots by ThermoWeb.

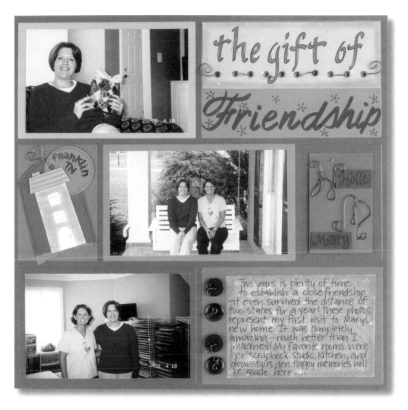

Contents

See page 74 for how to letter on a plastic tote.

See page 69.

See page 48.

Debra in her studio

Welcome

My love for calligraphy and hand lettering began over 30 years ago. I remember watching my grandmother as she hand lettered works of art and I couldn't wait for her to show me how to write the way she did. My grandmother gave me my first calligraphy nibs, nib holder and ink to get me started when I was about 7 years old. I'll never forget how much this gift meant to me and how excited I was that I was going to learn how to be a calligrapher like Grandma.

Grandma assured me that I could do it and gave me tips on how to use my new tools—she told me to always pull my strokes and be very careful to not make any ink blots while writing. I would watch her intently and mimic every move she performed. After a lot of watching and practicing, I became proficient at calligraphy.

As I grew older, I loved making posters in calligraphy for activities at school— homecoming, pep rallies, you name it. All of my school book covers were covered with my creative lettering and doodling. I loved coming across neat lettering styles and imitating them and making them my own. Lettering al-

lowed me to express my teenage heart on anything I could write on.

When I turned 15, my grandmother gave me my first set of fountain calligraphy pens. This has been one of the most special gifts I have ever received. It was Grandma's way of passing her passion on to me.

I worked those pens all through college, writing calligraphy on the business school's Continuing Education Department course completion certificates. This job provided me with all of my college spending money. I also addressed invitations for many brides in Washington, D.C. during that time.

In 1989, as I was getting ready to graduate from college, the business school informed me they had just put in a new computer that would be replacing me. The computer would generate the calligraphy on all the certificates. I was heartbroken; my hand lettering and my personal touch had been replaced by a computer.

The boom in personal computers, so I thought, had killed hand lettering. I put my pens and markers up on a shelf, and there they stayed for many years.

Unique Gifts

This was a gift from Kate Childers (whose designs appear in this book). I plan to include it on a special layout about our friendship. Tags make unique gifts and it's fun and easy to include hand lettering on them.

My paternal grandmother Betty Kimble is a professional artist and calligrapher.

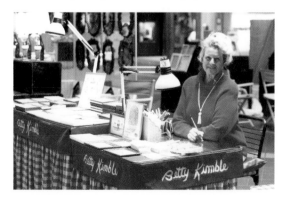

Enter the World of Scrapbooking

Then, in the late 90s a lettering miracle happened. A new hobby was emerging and taking off—archival scrapbooking.

As I became interested in scrapbooking and stamping, I found myself revisiting my old pens and using them in my scrapbooks. Whenever I shared my scrapbooks with others, they commented on my calligraphy. I heard over and over again from scrapbookers how they wished they could create beautiful lettering too. This interest and enthusiasm reminded me of my own desire that I had so many years before with my grandmother. Even with the easily accessible computer, people wanted to learn how to create their own hand lettering and calligraphy. They wanted to leave a part of themselves in their albums—to leave their own hand-written touch.

Thus began my mission to teach and show people how to create hand lettering. I wanted to demonstrate that *anyone* can do beautiful lettering and that hand lettering is important. As I began teaching my quick and easy lettering technique, it soon became evident that a book was needed, an all-encompassing lettering book.

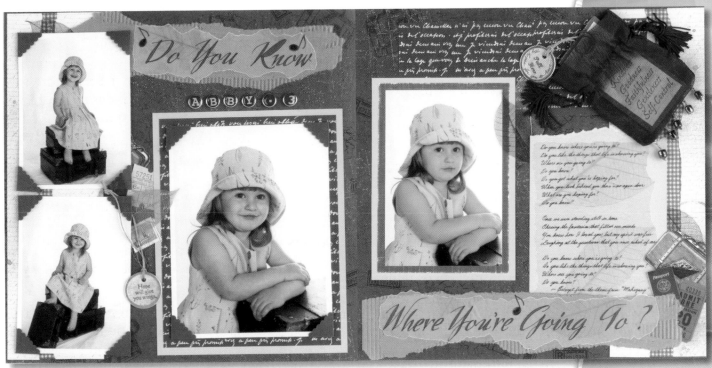

"Do You Know Where You're Going To?"
by Nancy Walker

ALPHABETS: Suzette #11

PENS: Marvy Medallion .03 and .01 black. Marvy Memories LePlume, light brown. Sakura 3D Crystal Lacquer

OTHER SUPPLIES: Paper by Clubscrap, Scrappapers.net, DMD, Seven Gypsies, Keeping Memories Alive, Current. Corner punch by Marvy Uchida; Circle punch by Carl. Adhesives by Glue Dots, 3M, Xyron and Hermafix.

DESIGNER NOTES: These photos of Abby sitting on suitcases brought the song used as the title to my mind. This page conveys a double meaning—future travel and where she is going as a person in this life. The fruits of the spirit are a natural for the little organdy bag.

The Suzette alphabet is fun and seems to go with my handwriting (if I take my time and be careful when I write!). The alphabet also symbolizes forward motion, adding to the theme of the page.

How to Use This Book

This book is the ultimate resource for anyone, of any age, of any artistic level, wanting to learn to create beautiful lettering. It demonstrates lettering on any surface or project and is packed with lots of timeless alphabets.

Anyone can learn to create beautiful lettering. I believe this with all my heart. If you want to learn, then you have taken the first step by opening this book. Sit back, relax and I will show you how!

You Can Do This

Have you ever admired creative lettering and thought, *I wish I could do that but my handwriting isn't very good and I really don't have time to practice.* Well you will be amazed to find that you *can* create stunning hand-crafted lettering.

Let's go back to kindergarten for a minute. Remember when you were first learning to write? You looked at letters, then you traced the letters, then you copied the letters. Soon you were on your own, printing and writing. You were actually developing the skill of training your hand to follow what your eyes were seeing. This is critical to understand.

Your hand will do what your eye and mind tell it to do. Think about your signature for a moment. See it in your mind. Now, without looking, write your signature on a sheet of paper. Then, right below it, write your signature again, this time while looking as you write. Notice how both signatures look almost identical.

Your eye and mind have seen you sign your name so many times that your hand will just do it automatically. Your hand has been trained to do what your eye and mind have seen.

Today
by Christy Kalbhin

Alphabet: Madison #26

Pens: Marvy Memories Artist, black

Other Supplies: Paper by Current. Scissor die cut by DMD. Crayon die cut by Ellison. Shoe is Christy's own design.

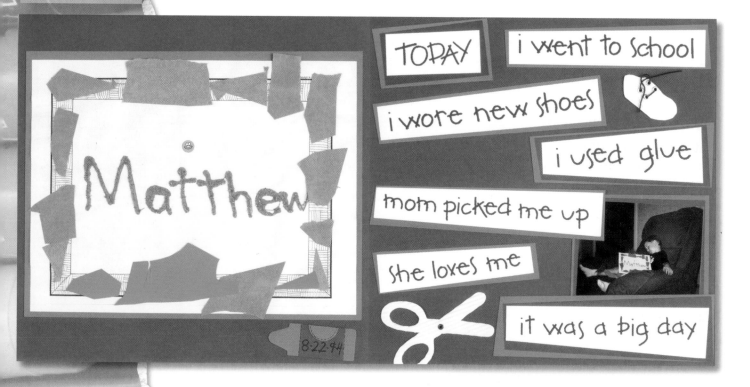

Ready, Set, Create

In this book, I will teach you tips and techniques to get your *hand* to do what your *eye* sees.

For lettering and calligraphy, tracing and copying are great tools to help you learn. Tracing and copying have long been used as valuable learning tools in the arts. This book is special because I have set up the alphabets to help you learn while you *create*.

The more you create, the better you'll get, until you are able to create different alphabets by just looking at them or even from memory. Be proud of all your lettering, including writing when copying and tracing, because it is *your* hand that has put those letters on paper. Your own personal expression will show through, even if you are tracing. It also shows your love and effort and your effort will be rewarded.

Creating things by hand, especially lettering, is part of the legacy of every generation. You leave a part of yourself behind and you add a little more beauty to the world. Learning this technique will give you the freedom to create so many beautiful things. You'll be able to create scrapbook pages and cards, decorate your home and objects with beautiful words, and make special personalized gifts for family and friends.

For Crafters of All Levels

This book is for all levels of experience. It teaches beginners easy ways to create beautiful lettering. For the advanced creative lettering artist, this book is full of unique timeless alphabets that you can quickly learn and reproduce, or make your own.

I have selected projects from a variety of artists and students who have taken my classes. Some of the contributors to the

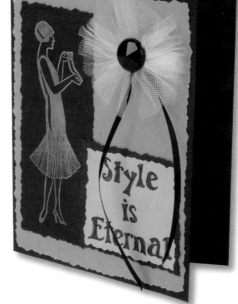

Style is Eternal Card
by Patricia League

ALPHABET: Catalina #15 reduced 50%

PENS: Marvy Memories Le Plume, black. Marvy Twinklette, gray.

OTHER SUPPLIES: Paper by Marco's Paper. Vellum by Close to My Heart. Party Pearls stamp and Brilliance ink by Hero Arts.

book have been published before. Others are being published for the first time and are excited to be sharing their newly found creative success.

As I worked on this book, I became aware of the resurgence of interest in hand lettering. It warms my heart to see students taking pride in their new skills.

This book has allowed me to relive the excitement of learning from my grandmother. It is my hope that it will be a valuable resource for all, and for many generations to come.

Debra

Calligraphy

Ever since I was a little girl watching my Grandma lettering in calligraphy, I have been fascinated with the art and its beauty. With its thick and thin strokes, calligraphy has a beautiful mystery, elegance and a tie to the past that calls our attention to it. It gives a certain grandeur to any project.

When I began scrapbooking I was using traditional metal calligraphy fountain pens. One day while shopping for ink cartridges, I discovered calligraphy markers. They were acid free and archivally safe and came in a variety of colors.

Calligraphy Markers Make it Easy!

At first, I intrigued with calligraphy markers, along with being a little skeptical. But soon I became a calligraphy marker aficionado. I have bought just about every calligraphy marker available to man (or woman), trying to find one that would mimic a traditional metal calligraphy pen.

The one thing that calligraphy markers have in common with traditional calligraphy pens is the *nib*—the point of the pen—which is wide, flat and chisel-like.

Calligraphy Markers. Most calligraphy markers come with a nylon nib at each end, usually of different widths. There are many brands and colors available. After experimenting with many different markers, I have found the Marvy Memories calligraphy pigmented markers to be the best. These markers have a nib of 2.0 mm on one end and 3.5 mm on the other end. Scrapbookers will be pleased to know that Marvy Memories markers are archival and acid free. The marker ink is the darkest and richest looking. It's the closest match to actual India ink used in traditional calligraphy. The key is not seeing the stroke overlay.

When purchasing a calligraphy marker, check the nibs. Make sure they do not have any nicks or bumps. Nicks will cause your lettering to look irregular. Also, be careful putting the cap back on the marker or you could ruin the nib.

Metallic Paint Markers. Calligraphy paint markers are a versatile addition to your writing supplies. The gold and silver are opaque. Metallic paint markers are good for paper, plastic, glass and wood. They also have nylon nibs.

Markers Make Push Ups Easy

While writing with traditional metal nib dip pens and fountain pens is exciting because it ties us to our past, it is much easier to learn calligraphy with markers. This is because you can both pull and push your strokes. (With traditional calligraphy pens, you must always pull the strokes.)

Calligraphy Made Easy

Over the years I have found the biggest struggle people encounter with traditional metal nibs is having to pull strokes. Complicating things further, students also have to maintain the proper pen and nib angle. It is difficult for people to put all of this together without becoming discouraged.

Once I began working with the calligraphy marker, I found that the nylon nib could be pushed *or* pulled. As long as I maintained the proper angle, I could create any lettering and achieve the thick and the thin strokes that make calligraphy so beautiful.

Calligraphy markers are easy for the beginning student to use. Once you gain confidence by lettering with calligraphy markers in your craft projects, you can move on to learning traditional calligraphy, which is more difficult and takes more practice time.

Supply List

Calligraphy Marker. Treat yourself to a variety of colors and nib widths. Always have black on hand.

Mechanical Pencil. This is a must. I recommend a mechanical pencil with a soft number two lead in it. Always press lightly when using your pencil. You will be erasing your pencil marks and do not want to leave an impression on the paper.

Erasers. I recommend the soft white eraser in a click pen by Pentel (looks like a pen with a white soft eraser in it instead). It is small enough to erase just the areas you want to erase. You can pick these up at any office supply or grocery store. I also like the soft white Mars Plastic eraser by Staedtler. Other types of erasers are hard and may ruin your paper.

Vellum Paper. Vellum makes creating great lettering and journaling easy and is great if you don't have a light box. You can use vellum to trace letters and then mount the title on cardstock.

Alphabets. Organize alphabets from this book and other favorite alphabets into a collection binder. This type of creative lettering collection makes future reference easy.

Light box. This is another "must have" for the beginner. You can even make your own light table; all you need is a glass table or some glass to write on, with a light source below. Light boxes make tracing on cardstock a breeze.

Learn by Tracing

The key to learning calligraphy with markers is learning how to hold the pen. Get relaxed and sit comfortably. Photocopy the worksheets from pages 92 and 93 or download them from www.debrabeagle.com.

Place your paper directly in front of you. Left-handers please see the special section on pages 30 and 31. Right-handers situate your paper straight in front of you, to the right just a bit and not tilted. Holding your marker, line up your marker nib with the diagonal line (a 45° angle) of the square on your worksheet. See the image below.

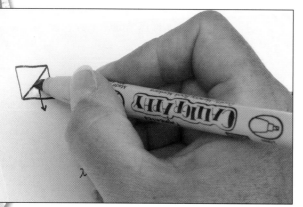

This is the customary hold of a calligraphy pen and is the basis for almost all calligraphy (this is the 45° angle that most have a difficult time imagining). Notice how the marker sits back in my hand and not straight up and down.

Don't turn your pen in your hand. Once you set your pen to paper, let it flow. Keeping the pen in the same position in your hand is what helps make the thick and thin lines as you write. Just imagine setting a ballpoint pen down on paper and beginning to write in cursive. The pen doesn't move around in your hand. The same applies to calligraphy. Once you set that 45° angle, keep the pen at that angle.

Next move your marker so that your nib lines up with the first down slash below.

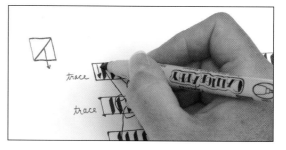

With this exercise, and those that follow, you *will see*, and then be able to do. Remember, like in kindergarten—*see* and *do*. Let's get the feel of the marker and practice. Begin tracing each of these down slashes. I cannot stress enough the importance of holding the marker at a 45° angle.

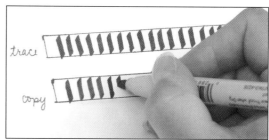

The tops and bottoms of your straight lines should appear slanted. After tracing, try copying. Keep your spacing even. Work at keeping those lines straight and not tilted. Focus on making sure you have the angles at the top and bottom of your lines, which indicates you have a good 45° angle hold. If you notice the bottoms of your lines are not angled but straight across you may be twirling the marker in your hand.

Next, try the short diagonal pen stroke. It looks like a square balancing on one of its corners. Set the 45° angle with your marker and pull towards the southeast, as though you were doing one bar of an *x*. Trace and then copy.

Next, let's try the horizontal bar stroke. Notice the triangle on each side of your bar. Set the 45° angle with your marker and pull to the right, as though you were crossing a *t*. Trace and then copy.

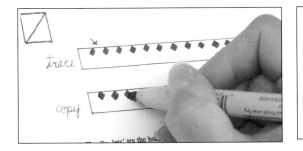
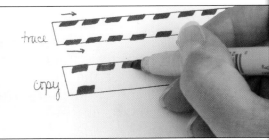

The Gothic Alphabet

By putting all three strokes together you can make the lowercase letters in the Gothic alphabet, which dates back to the Middle Ages. This is a great alphabet to start with because it helps you learn and understand pen strokes and the angle to hold the marker.

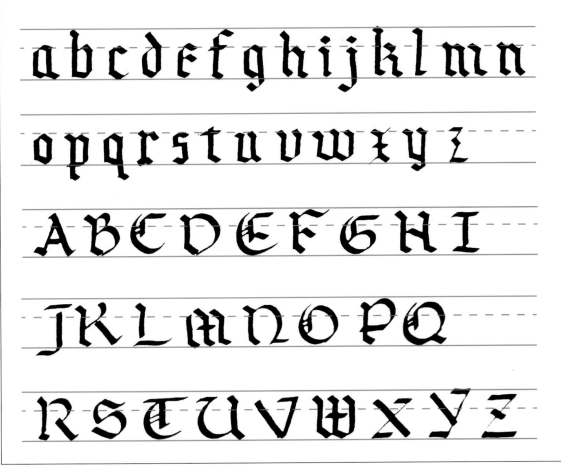

Capitals from this alphabet are great to use at the beginning of a paragraph or by themselves. Also notice how straight up and down this alphabet appears.

Letter Heights

Following the Middle Ages, people got tired of writing the Gothic alphabet and wanted something quicker and easier to read. Thus, during the Italian Renaissance, the Italic script was born. This is my favorite form of calligraphy. One can add many different things to this alphabet to dress it up or down. It is very versatile. It can be used on invitations, place cards, to address envelopes, and on scrapbook pages.

Before we get started with the Italic alphabet I'd like to discuss *letter heights*—how tall your letters should be. For almost every alphabet done in calligraphy, this is determined in nib widths. Each alphabet has a different recommended height. The nib is laid end to end a set number of times. Italic letters are a total of 13 nib widths high.

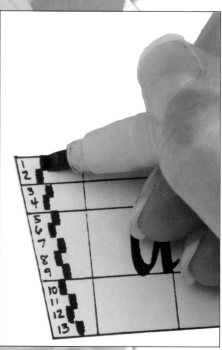

The main body of italic letters is as high as 5 nib widths of the pen you are using (lower case *o*, *e*, *a* etc.). The ascender (lower case *h*, *k*, *l*, etc.) and descender (lower case *j*, *g*, *p*, etc.) parts of letters are 4 nib widths higher and 4 nib widths lower, for a total of 13 nib widths.

Capital Italic letters are 7 nib widths (5 from the body and 2 higher).

Basic Italic can be broken down into 5 groups of letter bodies. You have *a*-body, *b*-body, rounded, diagonal, and straight letter bodies. (Use page 93 from the back of the book to practice.)

A-body and b-body letters come out of what we call *the box*. I have indicated where to begin each letter with an asterisk.

Set the marker nib on the 45° angle and then move the marker to the asterisk, maintaining the 45° angle, and trace your letter.

See the examples below and use the worksheet on page 93 to practice:

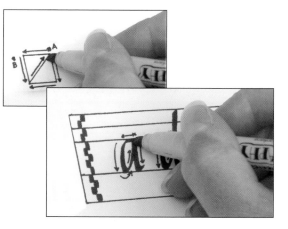

a-body letters: one continuous stroke

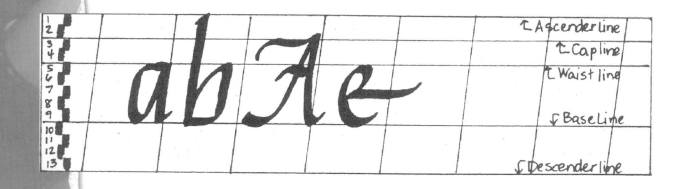

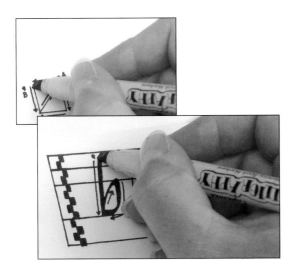

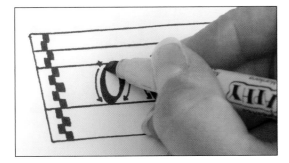

b-body letters: one continuous stroke

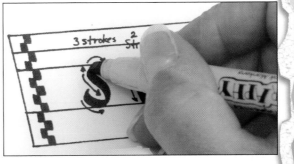

Diagonal letters.

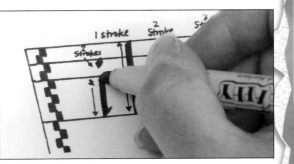

Straight letters.

Rounded letters: two strokes. Begin both strokes at the same spot. Notice the left side of both the *o, c,* and *e* are exactly the same.

Follow the Arrows

All of the calligraphy alphabets I have provided in this book have arrows indicating the direction of your strokes. Remember if you maintain the 45° angle you will be able to trace any letter correctly.

Christmas Page Topper
by Debra Beagle

ALPHABET: Betty #8

PENS: Marvy Memories Calligraphy, English red. Marvy Memories Le Plume, English red and jungle green. Marvy Twinklette, yellow green.

Tracing on Vellum

Now we are ready to try writing in calligraphy. To use this technique, first decide what you want to write. For this example, I've chosen the word *Dream*. Let's trace it on a piece of vellum using calligraphy alphabet Stephania #1 and a calligraphy marker with a 3.5 mm end.

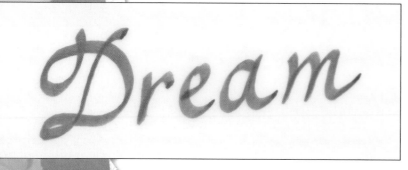

1 On a clean sheet of vellum, lightly pencil in your bottom guideline. You can easily make a guideline by taking another piece of paper and laying it across the vellum about 2 inches from the top, lining one end of the paper up with the edge of the vellum.

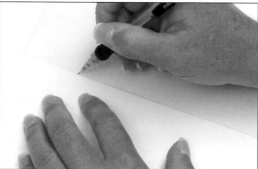

This will give a straight edge to run the pencil along. After drawing your guideline, flip the vellum over. You will write your calligraphy on the clean side of the vellum and yet can still see your guideline. If using cardstock, follow the above directions except all your writing will be done on a light box.

Space & Trace

All of the alphabets in this book are layed out and spaced to follow this method. And remember, your own personal expression will show through, even if tracing.

2 Now lay the paper over the first letter *D*. Make sure you line up your guideline under the bottom of the letter and that your guideline is level with the bottom of the row of letters that the letter you are tracing is on. Set the 45° angle (go back to the square with the diagonal line if you need to) and trace your letter.

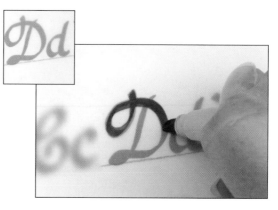

3 Now move to your next letter, the *r*. Take your paper and lay the *D* over the capital *R*, making sure the outer edge of the *D* lines up with the outer edge of the capital *R*. The lower case *r* is now next to your *D* and the spacing is already done for you. Make sure your guideline is level with the bottom of the row of letters that the letter (in this case the *r*) you are tracing is on.

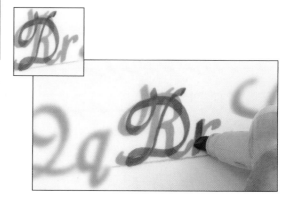

4 Next, line up the lower case *r* over the capital *E*, making sure the outer edge of the *r* lines up with the outer edge of the capital *E*. The lower case *e* is now next to your *r* and the spacing is already done for you. Make sure your guideline is level with the bottom of the row of letters that the letter (in this case the *e*) you are tracing is on and trace.

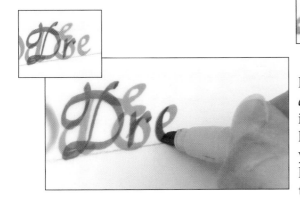

5 Continue repeating this until you have finished your word. Then erase your guideline.

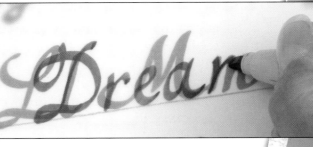

Don't worry that you are tracing. You *are* learning, by tracing. You are teaching your eye and hand to work together, learning while you do. The more times you use this method, the better your calligraphy will get, until you won't need to trace anymore. (See page 37 for the side-by-side lettering technique.)

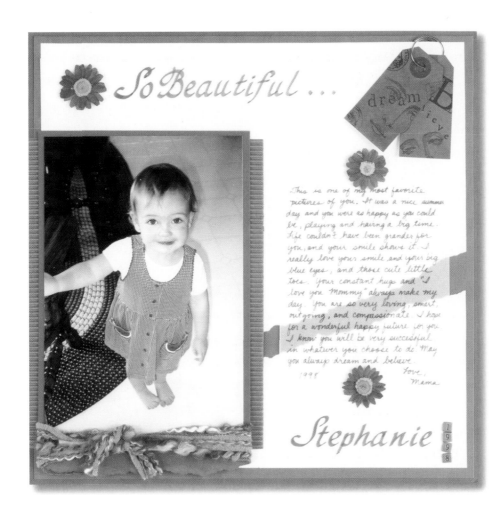

Gain Not Pain

Your wrist should not hurt while writing in calligraphy. If it does, you are holding your marker too tight.

Stroking in Silence

When making a stroke, you should not hear any noise. If you do, you are pushing too hard on the paper. Loosen your grip and pressure. Have fun!

So Beautiful Scrapbook Page
by Debra Beagle

ALPHABET: Stephania #1

PENS: Marvy Memories Calligraphy, English red. Marvy Memories Le Plume, fine tip, English red.

OTHER SUPPLIES: Paper and vellum by Paper Adventures. Corrugated paper by DMD. Small alphabet stamps, Grace alphabet, by Performance Art Stamps. Large alphabet stamps by DaVinci. Adhesive by Glue Dots.

Embellishing with Flowers

There is nothing prettier than embellishing a word with flowers. Using brush tip markers makes it easy. I have provided a step-by-step example in the margin of the next page that you can copy and trace. Again, by tracing, you are teaching your hand to do what your eye sees, this makes it easy for beginners to get it right. If you choose, you can try it free hand.

Using the brush marker, lay the tip down on its side, point end in, to create the petals of the flower. The brush tip is pretty resilient so you can press down to create a tear drop. Go around in a circle and make six petals pointing inward.

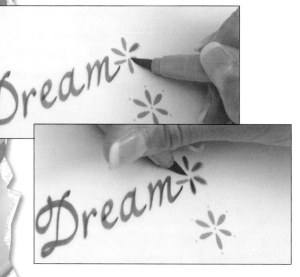

Use a fine tip marker (or the fine tip end of the Marvy Memories Le Plume) to dot the outside of each petal and the center.

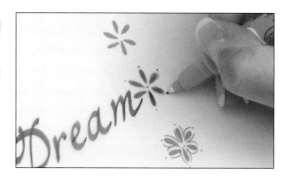

Add an outline to petals.

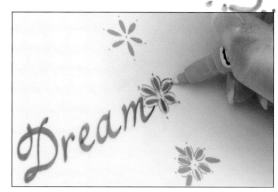

Using a green-colored brush tip marker, create the leaves of the flower, laying the tip down on its side point end out this time. Go around and in between the petals, make three leaves all pointing outward.

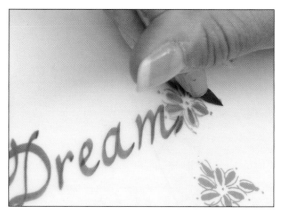

Then, using the fine tip jungle green marker, dot the outside of each leaf and outline each leaf.

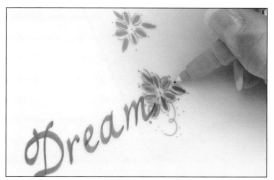

Again, using a fine tip green marker, draw vines and make three dots at the end of the vine and along the vine.

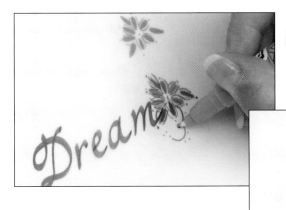

You can make the leaves and vine glitter by going over the jungle green leaves, vines, and dots with a yellow green Marvy Twinklette or glitter marker.

Gallery

Cattitude
by Wendy Pannell

ALPHABET: Nicolette #3 reduced 50%

PENS: Marvy Memories Calligraphy, 2.0 nib, black.

OTHER SUPPLIES: Cat stamp by Rubber Stamp Ave. Stamped with Versamark ink and black detail embossing powder by Ranger Industries. Pawprint charms from Fancifuls, embossed with Rubber Dub Dub silver embossing powder.

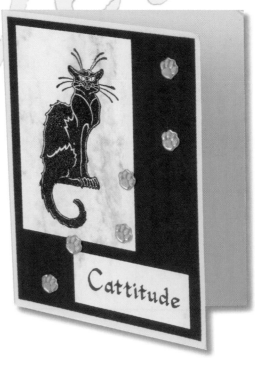

Tea Party
by Holle Wiktorek

ALPHABET: Stephania #1

PENS: Marvy Memories Calligraphy; Marvy Memories Artist, broad tip.

OTHER: Paper by DMD—Paper Reflections cardstock and Victorian Collage Papers. Metal keyhole charm by Lil Davis. Quilled flowers by Marilyn Clark. Peel n Stick Zots by ThermoWeb.

DESIGNER NOTES: Hand lettering personalizes this layout. Outlining the black title softens the lettering. A light colored cardstock or cardstock with a white back is helpful when tracing the alphabet on lined paper on a light box.

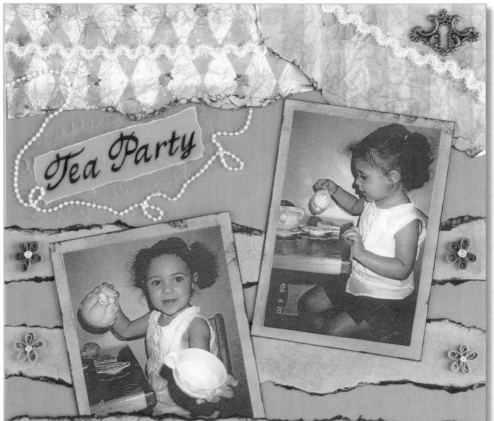

Fall Fantasy

Sometimes we forget to see the beauty of the place in which we live.

Fall Fantasy
by Karen Moffatt

ALPHABET: Stephania #1

PENS: Marvy Memories Calligraphy, English red.

OTHER: Paper by Rebecca Sower.

DESIGNER NOTES: I wanted something that floated. This alphabet is perfect and so easy to create.

Something to Chew

Bones, socks, and balls are comforting chew toys when the family is preoccupied with chores, careers, and hobbies. Each toy serves a purpose: the bone prevents tooth decay; the ball rolls for Harley to chase and exercise; and the socks remind Holle of their evening walk.

Something to Chew
by Holle Wiktorek

ALPHABET: Celia #4

PENS: Marvy Medallion; Marvy Memories Calligraphy

OTHER: Paper by DMD—Paper Reflections cardstock, corrugated paper, collage papers. Vellum by Over the Moon Press. Star brads and eyelets by Creative Impressions. Buttons by Dress It Up. Peel n Stick Zots by ThermoWeb.

DESIGNER NOTES: Tan cardstock was light enough to use on the light box to ensure perfect lettering and straight lines.

Harley

Addressing Envelopes

Use the 2.0 mm nib of a calligraphy marker, a light box and one of the small calligraphy alphabets.

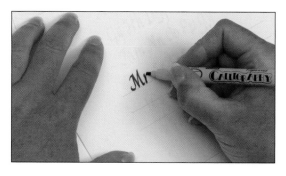

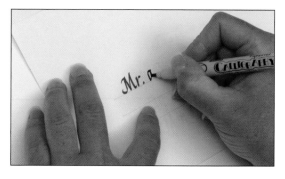

Draw three guidelines using a pencil on the outside of your envelope.

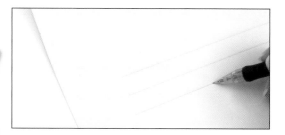

Cut out the alphabet so it will fit inside the envelope and then follow the calligraphy technique you learned in the previous chapter.

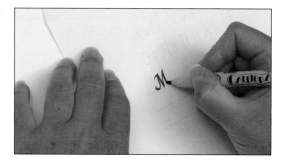

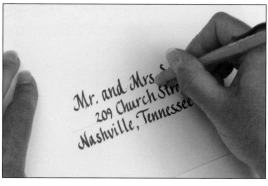

Wonderful Weddings

Wedding projects and calligraphy go great together. Hand-lettered envelopes, place cards, scrapbook pages or cards are more beautiful when lettered with calligraphy.

Add flowers as presented before.

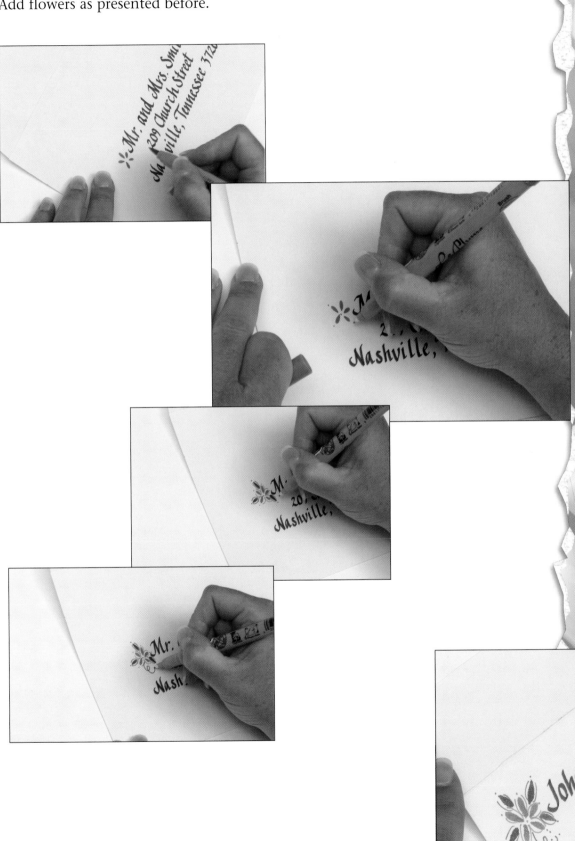

Gallery: Wedding

Wedding Day and Topper
by Debra Beagle and Pamela Lange for K&Company

ALPHABET: Stephania #1

PENS: Marvy Memories Calligraphy and Le Pluma; English red and jungle green.

OTHER: Paper and stickers by K&Company. Vellum by Paper Adventures.

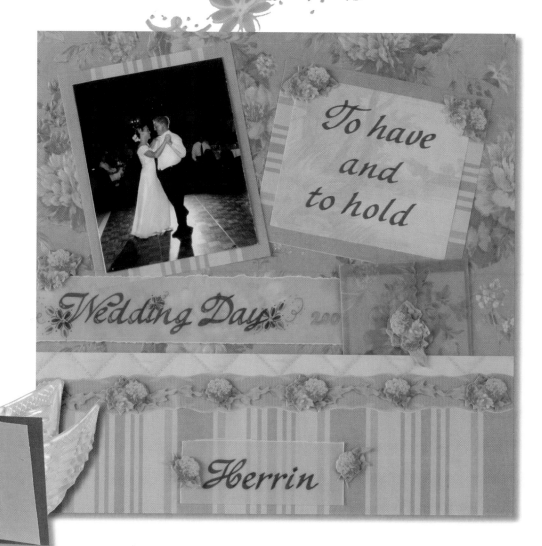

Place Card
by Gail Golliher

ALPHABET: Stephania #1

PENS: Pure red 2.0 by Zig.

OTHER: Punch by Fiskars. Frosted vellum by Hot off the Press.

DESIGNER NOTES: These were made for a rehearsal dinner. I wanted to show the guests that I appreciated all that they had done for us.

Wedding Day Page Topper
by Debra Beagle

ALPHABET: Stephania #1

PENS: Marvy Memories Calligraphy, wisteria.

DESIGNER NOTES: For a step-by-step template to make this page topper, see the 2nd to last page of this book.

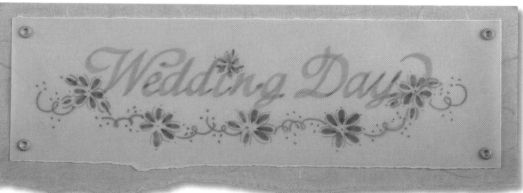

Gallery: Heritage

Tradition Scrapbook Page
by Debra Beagle and Pamela Lange for K&Company

ALPHABET: Gloria #12

PENS: Marvy Memories Le Plume marker, Prussian blue. Outlined with Marvy Medallion .03, black.

OTHER: Paper and stickers by K&Company.

DESIGNER NOTES: Even though this page was created with a fill-in alphabet, any of the calligraphy alphabets can be given a fill-in look by outlining them with a drawing marker

Photo Caption from a Heritage Page
by Debra Beagle

ALPHABET: Holle #2

PENS: Marvy Memories Calligraphy, 2.0 nib, English red.

DESIGNER NOTES: Calligraphy just seemed so appropriate and added elegance to this photo of my maternal grandmother.

Heritage Colors

Some good Marvy Memories colors for heritage projects are jungle green, English red, dark brown, Prussian blue, burnt umber and black.

For heritage flower petals or embellishments, try mustard, English red, cherry, magenta, and burnt umber. For the leaves and vines, use jungle green.

Embellishing with Grapes

Another way to embellish a word is with grapes using brush tip markers in purple and green. I have provided a step-by-step example to the right that you can copy and trace. Once again, by tracing you are teaching your hand to do what your eye sees.

Using the brush tip end of the purple marker, lay the tip down on its side, point end in and upward, to create the grapes. The brush tip is pretty resilient so you can press down to create a tear drop. Go down one side and then down the other.

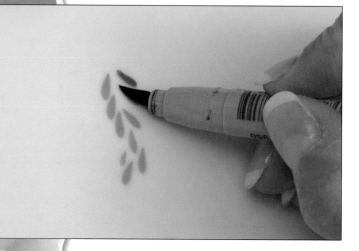

Then, using the fine tip end of the marker, outline the outside of each grape.

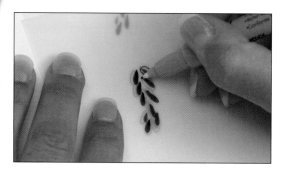

Using a jungle green colored brush tip marker, create the leaves of the grapes, laying the brush tip down on its side point end out this time. Go around on the top of the grapes, making 7 leaves all pointing outward.

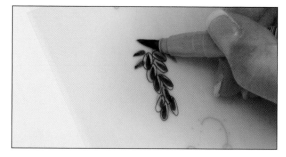

Then, using the fine tip end of the Le Plume jungle green marker, outline each leaf, draw vines and make three dots at the end of the vine and along the vine.

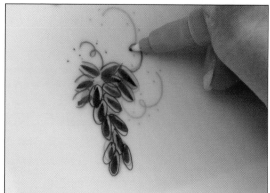

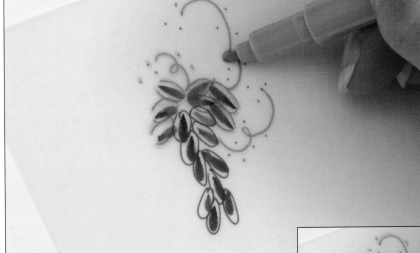

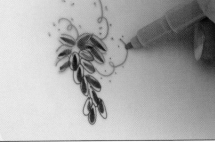

Note: You can make the leaves and vine glitter by going over the jungle green leaves, vines and dots with a yellow green Twinklette glitter marker.

Wine Country Page Topper

by Debra Beagle

ALPHABET: Stephania #1

PENS: Marvy Memories Calligraphy, red. Marvy Memories Le Plume, purple and jungle green. Marvy Twinklette, yellow green.

DESIGNER NOTES: You can add your own flairs and personal touches to make the lettering your own. I typically add flourishes to the beginning or end of words (see the *y* in *Country* below and the *s* in *Christmas* in the example on page 13).

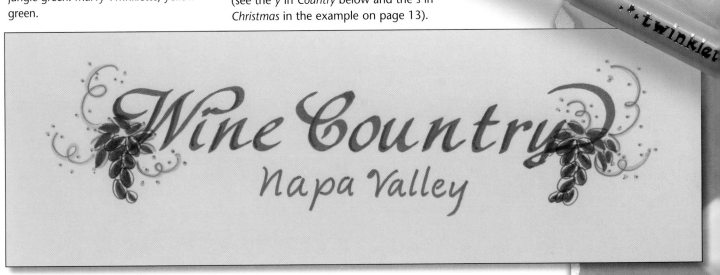

Gallery

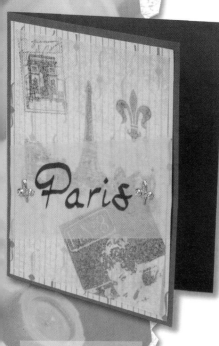

Paris Card
by Donna Luncford

ALPHABET: Lizbeth #7

PENS: Marvy Memories Calligraphy Marker, 3.5 nib, black.

OTHER SUPPLIES: Paper from Club Scrap. Ink from Clear Snap. Stamps from Stamp Cabana, Hero Arts and Stampington & Co.

DESIGNER NOTES: "Paris" needed a special lettering alphabet just like this.

Ocean Tag
by Victoria Bowling

ALPHABET: Stephania #1

OTHER SUPPLIES: Tag template by Fiskars. Fibers by Adornaments. Foil embossed and antiqued with Cherished Memories black paint. Adhesive by Miracle Sheets.

DESIGNER NOTES: I traced the word *Ocean* onto vellum and then placed the vellum on top of the metal. I traced the lettering onto the metal using a stylus embosser. (I passed over the wording two times.) Then, I applied black pearl ex directly to the metal over the word *Ocean*. I allowed the black pearl ex to settle into the indentions for a few minutes, then gently wiped it off.

Never Lose Your Sense of Wonder
by Victoria Bowling

ALPHABET: Maria #9

PENS: Marvy Memories Calligraphy, 3.5 nib, black. Slick Writer for writing on mirrors.

OTHER SUPPLIES: Amy's Gold Metallic Leafing, orange shimmer. Orange micro-fine glass by Treasured Memories. Mirrors by Darice. Red line tape by Magic Scraps.

DESIGNER NOTES: I hand lettered the titles onto vellum, then applied Xyron adhesive. Next, I applied orange shimmer metallic gold leafing to the back of the vellum to create a colorful, shimmering backdrop that was slightly muted by the vellum.

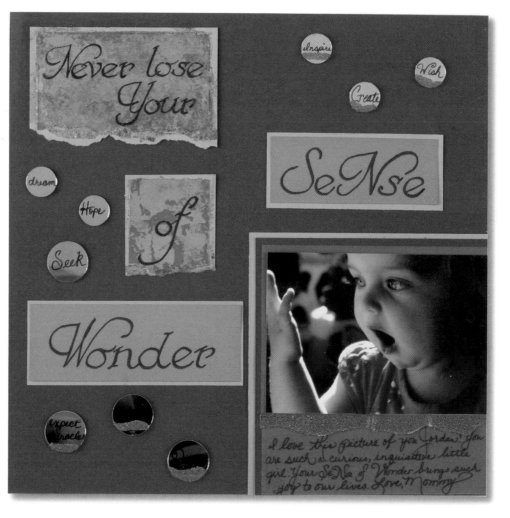

Gallery

Amour Card
by Patricia League

ALPHABET: Stephania #1 reduced 50%

PENS: Marvy Memories Calligraphy, 2.0 nib, black

OTHER SUPPLIES: Rosette heart by Stampington & Co. Amour stamp by Stampabilities. Marvy inks in pink and crimson lake.

Noel Card
by Wendy Pannell

ALPHABET: Victoria #5

PENS: Marvy Calligraphy, gold, medium-point

OTHER: Poinsettia stamp by Hot Potatoes. Brilliance ink in galaxy gold.

Oriental Spring Card
by Donna Luncford

ALPHABET: Linda #10

PENS: Marvy Memories Calligraphy, 2.0 nib, black. Marvy Le Plume II, aqua grey and pale orange.

OTHER: Paper from Club Scrap. Vellum from Paper Reflections. Oriental garden stamp from Stampin' Up.

DESIGNER NOTES: This alphabet was perfect for a spring theme card.

Gallery

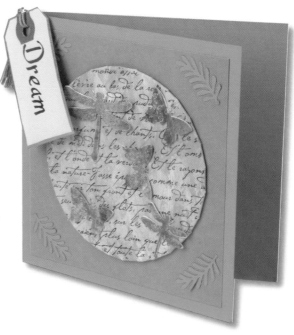

Dream Card
by Bonnie Lees

ALPHABET: Holle #2 reduced 50%

PENS: Marvy Memories Calligraphy, 2.0 nib, black.

OTHER: Stamps by Stampin' Up. Punches by McGill and Family Treasures. Ice Stickles glitter glue by Ranger Industries. Old CD used with marbled paper to form circle. Handmade marbled paper created by using white foam shaving cream and acrylic paints.

Baby
by Christy Kalbhin

ALPHABET: Stephania #1

PENS: Marvy Memories Calligraphy, sapphire.

OTHER: Paper by American Crafts. Tagged hearts by Making Memories.

DESIGNER NOTES: The words were written on white cardstock and then overlayed with vellum. I would have never written this large in my own handwriting. With a light box and Debra's alphabet, it was easy to keep the letters the same size.

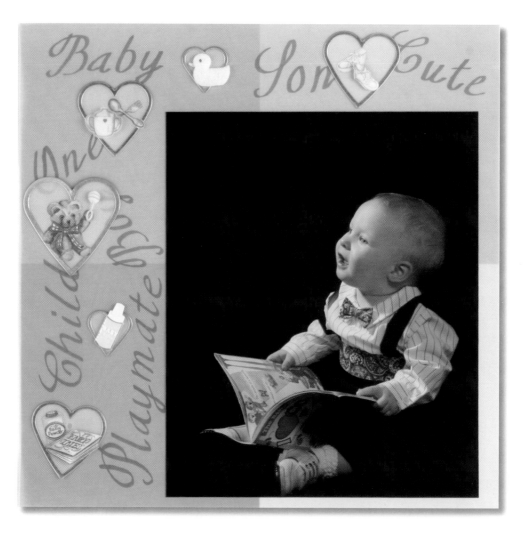

Gallery

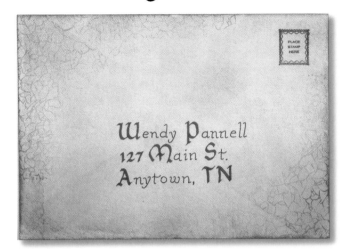

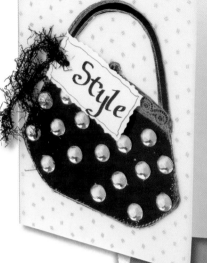

Envelope
by Wendy Pannell

ALPHABET: Victoria #5 reduced 50%

PENS: Marvy Memories Calligraphy, 3.5 nib, black.

OTHER: Crackle stamp by The Stamp Pad. Postage stamp by Stampin' Up.

Style Purse Card
by Marilla Naron

ALPHABET: Holle #2

PENS: Marvy Memories Calligraphy, 3.5 nib, black.

OTHER: White and black glossy card stock.

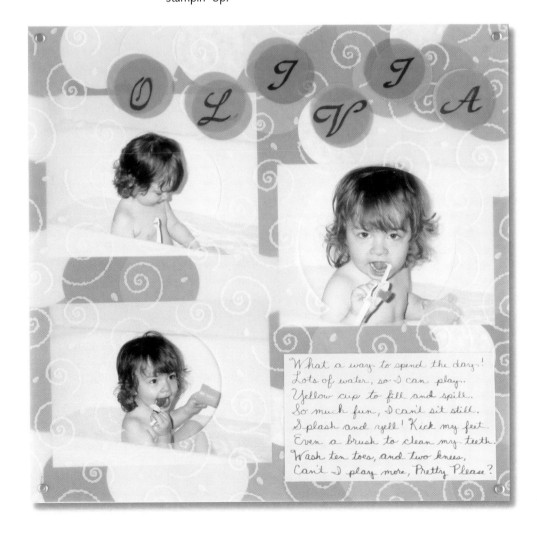

Olivia
by Christy Kalbhin

ALPHABET: Stephania #1

PENS: Marvy Memories Calligraphy, 3.5 nib, black and steel blue. Marvy Memories Artist, black.

OTHER: Paper by Colorbok, Memories Forever and MPR's Paperbilities.

DESIGNER NOTES: I wrote the poem and made the background paper out of punched circles.

Left Handers

While working with left-handers over the years, I have found there are two types—those who write straight across and those who write with a hook. I'd like to address both types in this section.

I have had great success teaching left-handers who have previously struggled with calligraphy. The calligraphy marker has truly opened the door for left-handers because of the simple fact that you can sometimes push a stroke, which you cannot do in traditional calligraphy. If you are a left-hander and follow my approach of learning calligraphy—though it may seem unconventional—you will have success.

The approach below has come together by working with hundreds of left-handers over the years, listening to them, and seeing their results. You can do it!

Straight Across Left-Handers

To get started, relax and sit comfortably. Make a copy of the worksheet on page 92. Place this worksheet directly in front of you. Turn your paper clockwise to the 3:00 pm position and then place your nib so that it lines up with the diagonal in the box. (See the top photograph on the next page.)

Holding your marker, reposition the nib with the first down slash that we will be tracing—except that you will not be pulling *down* but *across* to your left. As you write each line, make sure to keep the 45° angle at the end of each line. This confirms that you are maintaining a 45° angle. (Look at the lower bottom photograph on the next page.)

By positioning the paper as in the photograph, you are able to get the 45° angle without contorting your body into an odd position. As you continue to follow all the steps outlined in this book, keep your paper turned to 3:00 pm position. This makes it much easier to maintain the 45° angle.

Remember, you are teaching your hand to do what your eye sees. The 45° angle is critical. If the paper is not turned correctly, it will be very difficult for you to achieve and maintain this angle.

Left-Handers with a Hook

In working with hook left-handers, I have found that it is best to situate your paper as a right-hander would. Here again, the calligraphy marker is a blessing for you because it allows you to *push* strokes. What is important is the 45° angle. Once you have this—regardless of how you work the marker—you will be able to create calligraphy letters.

Almost all of your strokes will be *push* strokes. Position your marker on the other side of the 45° angle. When making your down strokes, push them. Whenever the directions in this book say to pull a stroke, you will be coming from the other side and pushing. This method is very non-traditional in calligraphy, but when you use the calligraphy marker in this manner, you will be successful.

As long as you maintain the 45° angle with the marker, you can push or pull your letter strokes. The more you trace and copy, the quicker you teach your hand to do what your eye sees.

Nib Positioning for Straight Left Handers

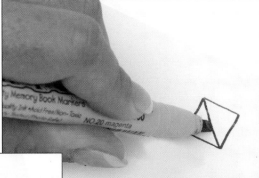

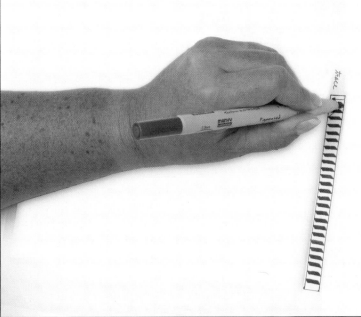

Regardless of the direction you are pushing or pulling your strokes, if you are maintaining the 45° angle, your letters will be drawn correctly.

For Nylon Only

Please note this technique will not work with a metal nib calligraphy pen.

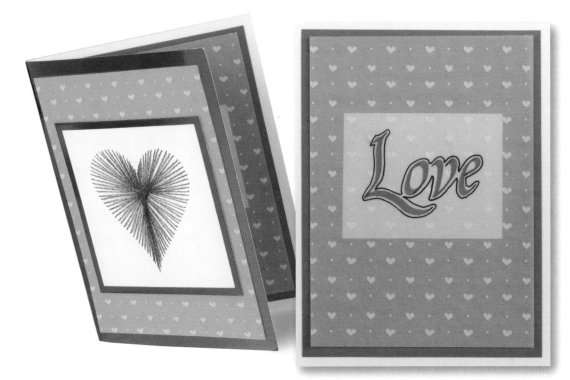

Love Card
by Wendy Pannell

ALPHABET: Bonnie #6

PENS: Marvy Memories Calligraphy, 3.5 nib, red. Outlined with Marvy Medallion .03, black.

OTHER SUPPLIES: Heart on cover stitched with DMC metallic red embroidery floss.

Creative Lettering

"**B**eautiful creative lettering, oh how I wish I could do that!" I hear it all the time. So many of us would love to be able to make our own titles anytime and anywhere. Either we don't have access to a computer or we just want to add our own personal touch to our scrapbook pages and projects.

Learning how to do creative lettering opens up a whole new world of artistic projects. Anyone can learn how to create hand lettering. Believe that. Know that you can do it!

It's okay if you think your handwriting isn't very good, that creative lettering looks difficult to do, or that you really don't have time to practice. I am going to show you that you *can* create beautiful lettering.

Again, let's go back to kindergarten. Remember when you were first learning to write and you looked at letters, then you traced the letters, then copied the letters, and soon you were off on your own, printing and writing.

You were training your hand to follow what your eye saw. This approach also works for learning creative lettering.

Once you learn how, you can take that skill and apply it to scrapbook pages, cards, fabrics, furniture, walls and any other craft projects as you will soon see.

Supply List

Listed below are the supplies and the manufacturers I recommend for creative lettering. I include recommended products to save you time since I have experimented with a wide variety of supplies.

Pencil. This is a must. I recommend a mechanical pencil with a soft number two lead in it. Always press lightly when using your pencil. You will be erasing your pencil marks and do not want to leave an impression in the paper.

Erasers. I recommend the soft white eraser in a click pen by Pentel (it looks like a pen with a white soft eraser in it instead) or the soft white Mars Plastic eraser by Staedtler. Other types of erasers are hard and may ruin your paper. The click pen eraser is small enough to erase just the areas you want to erase. You can pick these up at any office supply or grocery store.

Drawing Pens. Keep a stock of a variety of sizes: .005, .01, .03, .05 and .08. My favorite is the Marvy Medallion. Use drawing pens to outline your letters and to journal. Most drawing pens dry quickly and won't smear on vellum.

Make sure the pen you use is archival and acid-free. I recommend the .03 size for outlining letters and the .005 or .01 sizes for creating faux stitching around titles. The .05 and .08 sizes are great for journaling.

Vellum Paper. Use heavyweight vellum. If you don't have a light source, this is the next best thing. You can use vellum to trace letters and then mount them on cardstock.

Graph Paper. When it comes to helping improve your lettering and journaling, graph paper is the ticket. When combined with vellum, you can easily improve your handwriting. Lay vellum over the graph paper and you will automatically have your guidelines, spacing and letter height set for you. There is no need to draw guidelines.

Brush Markers. Brush markers give your letters a unique look. My favorites are the Marvy Memories LePlume and Marvy LePlume II. These brush markers also have a fine tip at the opposite end that is perfect for journaling in the same color.

Store Sideways

Always store your dual-end markers horizontally. It keeps the ink from settling at one end of the marker. If you accidentally leave a marker stored with a tip down, just lay the marker horizontally and the ink will even out over a short period of time. Storing vertically will also lighten or darken the particular color at each end.

Ring Binding

Gather all of the alphabets you like and put them in a 3-ring binder. This makes it easy to pull out the alphabet you want to use when tracing.

Broad Tip Markers. Use broad tip markers for printing titles. My favorite is the Marvy Memories Artist Marker. It has a thick broad tip at one end and a thin broad tip at the other. The Artist comes in colors that match the Marvy Matchables inks and the Marvy LePlume and Calligraphy markers.

Glitter Markers. My favorite are the Twinklette Markers by Marvy. These glitter markers come in eight colors. When storing these markers, it is best to keep the tip down. The markers are acid free and archival.

Light Box. Again, another must have if you are going to be hand lettering on cardstock. You can even make your own light table—you'll need a glass table or some glass to write on and a light source below this surface. A light box makes tracing a breeze.

Colored Pencils. My favorite are Prismacolor. They are creamy and rich in color and work great for coloring in letters. They blend beautifully, giving life to your letters.

Blender Pencil. A blender pencil doesn't have any color to it. It is used over different colors to blend them together. For creative lettering, it is used to blend colors on filled-in letters, giving a watercolor look. However, blending does tend to darken colors. My favorite is the Prismacolor blender pencil.

Chalks. Chalks are great for adding a little color around letters or coloring inside the letters. My favorite chalks are by Stampin' Up and Craf-T Products. You can use cotton swabs (my favorite kind is available at Sally's Beauty Supply—they are pointy on one end and somewhat flat on the other), cotton balls or eye shadow applicators to apply chalk. Pazzles also makes a wooden handle with a gripper on the end that holds small pom-poms which are useful for chalking.

Watercolor Pencils. Water color pencils give you a completely different option for coloring in letters. The colors are soft and muted when water is applied to the pencil coloring. My favorites are by Faber-Castell.

Waterbrush. Waterbrushes are great to use for blending watercolor pencils and tearing mulberry paper. Yasumoto makes a terrific waterbrush. Everything is self-contained and easy to use and refill. This brush is also great for kids to watercolor in coloring books. No cups of water needed and they can even watercolor in the car!

Liquid Glitter. Glitter adds a nice sparkle to your lettering. My favorite is Crystal Ice by Ranger Industries. It is acid-free and comes in a small bottle with a tip which provides neat, easy dispensing.

Paint Markers. Paint markers come in different tip sizes—broad, fine and extra fine—and many colors. These markers work great on plastic, glass and wood. It is best to store them horizontally or tip down. Consult the particular pen manufacturer for storage recommendations. My favorite paint markers are DecoColor markers by Marvy Uchida.

Fabric Markers. Use them to letter and draw on fabric or canvas. They are best stored horizontally or tip down. My favorites are the DecoFabric Markers by Marvy Uchida. They come in many colors including metallics and pearlized colors. There is also a Glow in the Dark DecoFabric marker that kids love.

Craft Markers. These are made for terra cotta pots, wood or paper. My favorites are Garden Craft Markers by Marvy Uchida. They are acid free, odor free, lightfast and permanent. They come in three sizes. The largest size is great for posters or large lettering. The white and gold are very opaque.

Lettering Templates. Templates are great to trace in pencil. You can modify the shapes slightly to give them your own personal look.

Alphabets & More Alphabets. My favorites are the timeless alphabets I've designed and provided in the back of this book. I also like the alphabets in the books *Scrapbook Lettering* by Memory Makers and *The Art of Creative Lettering* by Becky Higgins. Start a collection of alphabets that you like from books or magazines, keep them with your collection of alphabets. Old issues of *Creating Keepsakes* and *Memory Makers* magazines have alphabets laid out and spaced as my alphabets are so they work for my technique.

Tracing Letters

Expanding on what you have learned so far, we are going to select the alphabet Karina #14 (see the alphabets in the back of the book) and write the word *Rose* using the same approach that we did in the calligraphy chapter on pages 14 and 15.

The supplies you'll need are a piece of vellum, a .03 black drawing marker, a pink brush marker and the Karina alphabet #14.

Lightly pencil in your guideline. A quick way to make a guideline is by taking another piece of paper and laying it across the vellum about two inches down from the top and lining one end of the paper up with the edge of the vellum. This will give you a straight edge to run your pencil along.

Moving on to the next letter, take your paper and lay the *R* over the capital *O*. Because this alphabet has a long flair underneath, center the *R* over the capital *O*. The lower case *o* is now next to your *R* and the spacing is already done for you. Make sure your guideline is level with the bottom of the row of letters that the letter (in this case the *o*) you are tracing is on.

After drawing your guideline, flip your vellum over. You will do your lettering on the clean side of the vellum and yet can still see your guideline. If using cardstock, follow the above directions but do everything on a light box. For this practice exercise you can write the word *Rose* or you can select another word.

Lay your paper over the first letter *R*. Make sure you line up your guideline under the bottom of the letter and that your guideline is level with the bottom of the row of letters that the letter you are tracing is on. Trace your letter using your drawing marker.

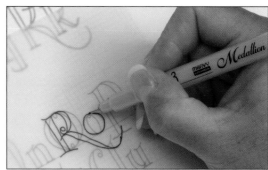

Next, line up your lower case *o* over your capital *S*, again making sure the *o* is centered over the capital *S*. The lower case *o* is now next to your *s* and the spacing is already done for you. Make sure your guideline is level with the bottom of the row of letters that the letter (in this case the *s*) you are tracing is on, and trace.

Continue repeating this until you have finished the word. Then turn your paper over and erase your guideline.

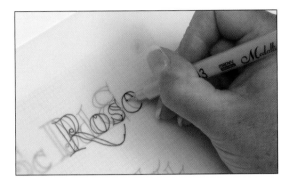

Color in the back side of the letters with the pink brush marker. After you have finished and turned your paper back over, you will have a title in which the color looks muted. It is a nice, subtle effect.

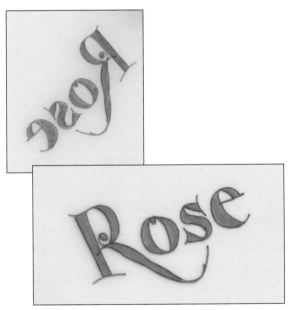

Again, you *are* learning by tracing. You are teaching your eye and hand to work together, learning as you do. The more times you use this method the better your lettering will get, until you won't need to trace anymore. You can choose from any of the alphabets in this book.

And remember, your own personal expression will show through, even if tracing. You can add your own flairs and personal touches to make the lettering your own.

Happy Father's Day Card
by Bonnie Lees

ALPHABET: Madison #26

PENS: Marvy Memories Artist, black; Krylon 18 kt. gold leafing pen

OTHER SUPPLIES: Stamps by PSX and Impression Obsession.

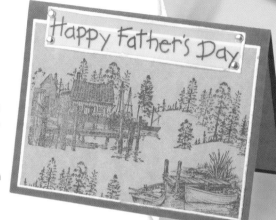

More Advanced Technique

Pick a clean sheet of vellum, or white paper if you have a light box. Use graph paper underneath for guidelines so you don't have to pencil in guidelines. Now try writing your word on your own while looking at a completed alphabet set next to where you are working. You are practicing getting your hand to do what your eye sees. Gradually, as your mind begins to remember what the alphabet looks like, you will be able to recall it from memory as you do your signature, and you will be able to recreate it without even looking at the alphabet!

Versatile Vellum
From penciling in guidelines to coloring in letters for a muted effect, the opposite side of vellum can be used as a design enhancement.

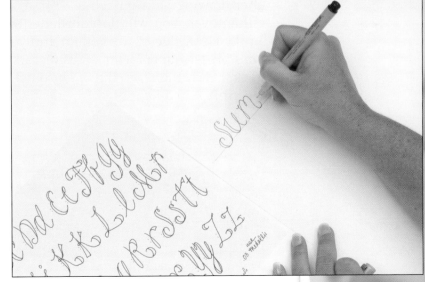

Brush Lettering

Brush markers give scrapbook page titles and cards a special flair. The lettering and stroke give projects beauty and style. Brush lettering is created in the same way as other creative lettering.

For this practice exercise we will write the word *Hope* (or you can pick any word you like) on vellum using brush alphabet Nanci #22 and an orchid-colored brush marker.

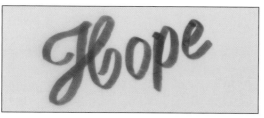

On a clean sheet of vellum, lightly pencil in your guideline. Then, flip your vellum over. You will do your lettering on the clean side of the vellum and will still see your guideline. If using cardstock, follow the above directions and use a light box.

Lay your paper over the first letter *H*. Make sure you line up your guideline under the bottom of the letter and that your guideline is level with the bottom of the row of letters that the letter you are tracing is on. Trace your letter with the brush tip marker. The harder you push down, the thicker the letters will be.

Now move to your next letter, the *o*. Take your paper and lay the *H* over the capital *O*, making sure the outer

edge of the *H* lines up with the outer edge of the capital *O*. The lower case *o* is now next to your *H* and the spacing is already done for you. Make sure your guideline is level with the bottom of the row of letters that the letter (in this case the *o*) you are tracing is on and trace the *o*.

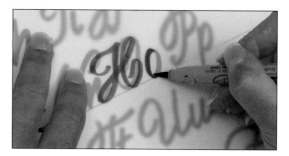

Next, line up your lower case o over your capital *P*, making sure the outer edge of the *o* lines up with the outer edge of the capital *P*. The lower case *p* is now next to your *o* and the spacing is already done for you. Make sure your guideline is level with the bottom of the row of letters that the letter (in this case the *p*) you are tracing is on and trace the *p*.

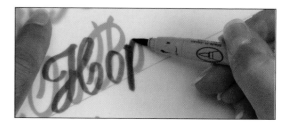

Continue repeating this until you have finished your word. Then erase the guideline.

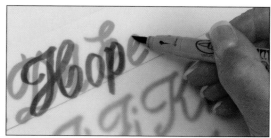

Brush Gallery

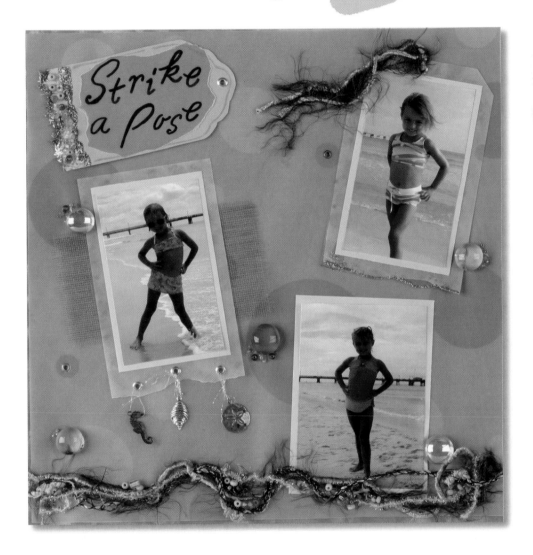

Strike a Pose
by Victoria Bowling

ALPHABET: Natalia #23

PENS: Marvy Memories Artist, black.

OTHER SUPPLIES: Metallic silver thread for charms by DMC.

DESIGNER NOTES: One of my favorite parts of writing my own lettering is that I never run out of letters in the middle of a layout!

Beach Page Topper
by Victoria Bowling

ALPHABET: Maria #9

OTHER SUPPLIES: Colored pencils by PrismaColor.

Staggering Letters

Hand lettering offers many different ways to make your creative lettering unique—many methods only you can do and a computer can't.

One variation is to stagger your letters up and down throughout the word.

On a clean sheet of paper, lightly pencil in your bottom guideline, then pencil in another guideline slightly above the first line.

After drawing your guidelines, flip your paper over. You will do your lettering on the clean side of the paper and still be able to see your guidelines. We will be using cardstock, so we will follow the directions and be doing everything on a light box.

We will do the word *Summer* on the cardstock using the alphabet Elena #13 and a black fine drawing marker.

Lay your paper over the first letter *S*. Make sure you line up your bottom guideline under the bottom of the letter and that your guideline is level with the bottom of the row of letters that the letter you are tracing is on. Trace your letter with the drawing marker.

Now move to your next letter, the *u*. Take your paper and lay the *S* over the capital *U*, making sure the outer edge of the *S* lines up with the outer edge of the capital *U*. The lower case *u* is now next to your *S*. Slide your paper down so that your *u* is now on the upper guideline. Make sure your guideline is level with the bottom of the row of letters that the letter (in this case the *u*) you are tracing is on. Trace the *u*.

Next line up your lower case *u* over your capital *M*, making sure the outer edge of the *u* lines up with the outer edge of the capital *M*. The lower case *m* is now next to your *u*, slide your paper up so that your *m* is now on the lower guideline.

Make sure your guideline is level with the bottom of the row of letters that the letter (in this case the *m*) you are tracing is on and trace the *m*.

Continue repeating this until you have finished your word. Then erase your guidelines.

Rocking Letters for Fun

Another variation is to rock your letters back and forth throughout the word.

On a clean sheet of paper, lightly pencil in your guideline. Then, flip your paper over. You will do your lettering on the clean side of the paper. We will be using cardstock, so we will follow the directions and be doing everything on a light box.

We will do the word *Fun* on the cardstock using the alphabet Elena #13 and a .03 drawing marker.

Lay your paper over the first letter *F*. Make sure your guidelines line up under the row of letters and that your guideline is level with the bottom of the row

of letters that the letter you are tracing is on. Pretend your letter is the center and pivot the paper to the right. Trace your letter with the drawing marker.

Now move to your next letter. Take your paper and lay the *F* over the capital *U*, making sure the outer edge of the *F* lines up with the outer edge of the capital *U*. The lower case *u* is now next to your *F*. Now pivot your paper to the left keeping your *u* as the pivot point. Trace your *u*.

Next line up your lower case u over your capital *N*, making sure the outer edge of the *u* lines up with the outer edge of the capital *N*. The lower case *n* is now next to your *u*. Pivot your paper to the left keeping your *n* as the pivot point. Trace your *n*. You now have *Fun*.

Camping Page Topper
by Victoria Bowling

ALPHABET: Celia #4

PENS: Marvy Memories Calligraphy. Marvy wet embossing pen.

DESIGNER NOTES: I traced the alphabet with a calligraphy pen first, then put the Marvy wet embossing pen over the lettering. After that, I applied high gloss Cloisonné granules and then heat embossed. The tiles are affixed with Glue Dots.

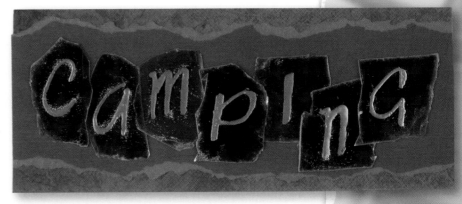

Coloring in Letters

In this section, you'll learn how to bring your letters to life, give them dimension and really make them pop.

Colored pencils are a great tool and work best on cardstock. Create a title using the technique presented on pages 36 and 37. Select an alphabet that would be a good fill-in alphabet. For this example, I have chosen an *A* from the alphabet Angelique #18 and a Prismacolor electric blue pencil. Lightly fill in the color all over your letter, in a swirling motion.

with this. The area of your lettering that you want to darken (or appear in the shadows) should be colored heavier. In other words, color the same side of *each letter* darker.

Adding a Shadow. Using a gray brush marker, drag the marker along an edge of your letter and it will give the letter a shadow effect.

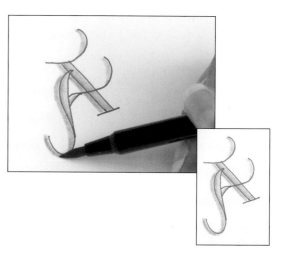

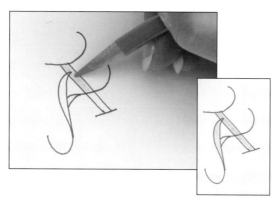

With the same color, you can color a little darker along one side of the outer part of the inside of the letter. If you color even heavier along the very edge of the letter, you will be rewarded with a gorgeous multi-dimensional appearance. Take a moment to imagine the sunrays hitting one side of your lettering. Imagine the opposite side of your lettering in the shadows. Stay consistent

Blend It. To blend colors together, you can use a blender pencil. This pencil does not have any color to it. It is used over colors to give them a watercolor look. Note that the blender pencil tends to darken the colors.

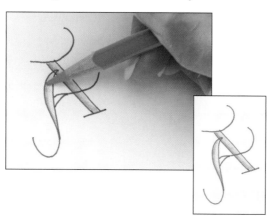

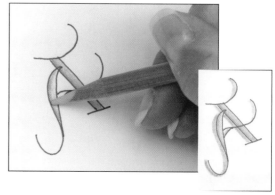

Using Two Colors

Two-color blends using colored pencils give your lettering a soft, multicolored look. First select two colors, one light and one just a little darker.

Begin by coloring in the letter, lightly, in a swirling motion over the top of the letter. For this example I used electric blue.

Then, color over the bottom half of the letter in a swirling motion with the second color. In this example, I used green apple. This will give a smooth transition between the colors and avoids a hard line between the two colors.

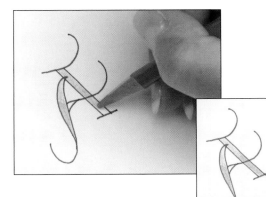

To truly blend the two colors in the letter together, use a blender pencil to color over the letter. This gives the colors more of a muted watercolor effect. Notice that the blender pencil will slightly darken the original colors.

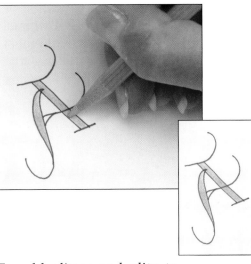

To add glitter and glitz to your letters there are two additional techniques you can try—liquid glitter and glitter markers.

Squeeze liquid glitter over letters to give them sparkle. Allow time for the liquid glitter to dry.

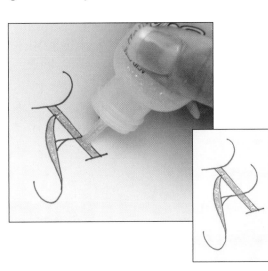

PrismaColor Combinations

Some suggested color combinations are red and violet, mahogany red and Tuscan red, lilac and violet, beige and electric blue (see the Beach Page Topper example on page 39), olive green and dark green, and pumpkin orange and terra cotta.

Glitter Markers

Glitter markers work well on their own or when used to highlight the top of already colored letters. They are great for coloring in letters and blend very well.

Glitter markers can even be used to highlight stickers. Coloring over stickers with a Marvy Twinklette marker will add glitter to the sticker. Or you could use a yellow green Marvy Twinklette marker to highlight leaves and vines when drawing flowers.

When coloring in letters I usually select two colors. I select a light color and a slightly darker color. This combination is commonly located side-by-side on the color wheel.

The example shows coloring a letter with orange on the top and then pink on the bottom.

As you color in the pink portion of your lettering, stroke the pink ink up into the orange ink. This type of blending gives a smooth transition between the colors and avoids a hard line between the two.

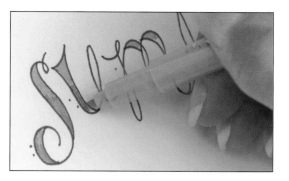

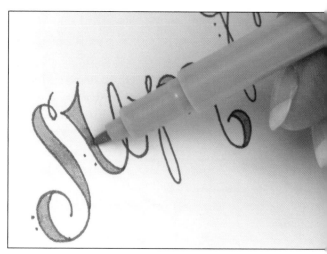

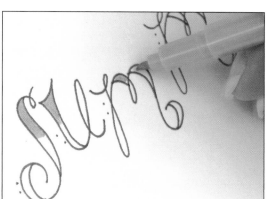

Sparkling Pairs

My favorite combinations of Marvy Twinklettes are orange and pink, yellow and orange, yellow and yellow green, blue and purple, and green and blue.

Watercolor Pencils

This technique gives you a very muted watercolor look.

First, very lightly color in your letter with a watercolor pencil.

Then, take a waterbrush and wet the area that you colored in pencil.

Then with the waterbrush, go over the watercolor pencil marks to achieve the watercolor look.

You can easily create the look of water and splashes around a letter or word by lightly coloring in the water and splashes with a blue watercolor pencil. Remember to keep a light touch when coloring using this technique. If you press too hard with your watercolor pencil, you will see the pencil marks even when you add water.

If you wish to achieve a variegated look, add a bit of green watercolor pencil. This will add depth.

Vacation Fun
by Debra Beagle

ALPHABET: Christy #16

PENS: Marvy Memories LePlume, fine tip, jungle green. Marvy Medallion .03, black.

OTHER SUPPLIES: Paper by Bazzill Basics. Watercolor pencils by Faber-Castell. Tiles by Magic Scraps. Fibers by ProvoCraft. Sun charm by Darice. Adhesive by Glue Dots.

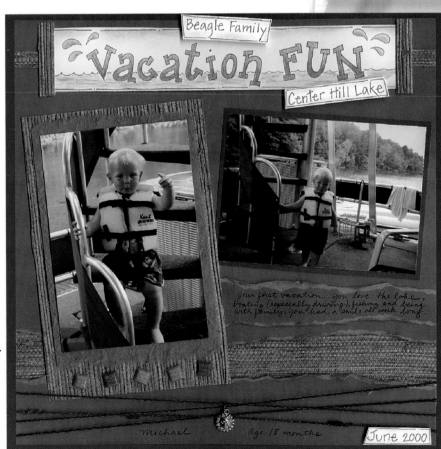

Filling in with Chalk

Chalks are fun to use and give a very soft muted look. After you have drawn your letters, chalk adds a little color inside or around letters. I like to use Q-tips. Chalk may also be applied with cotton balls, make-up sponges or eye shadow applicators.

First, dab your cotton tip in a chalk color. Dust off any excess on an extra piece of paper and then dab the chalk on your letter. It is okay if the chalk goes outside the letter's outline. This adds to the effect.

to go with any color scheme. I hand letter almost all of my titles on a light color of paper and then chalk the paper to match my background paper color.

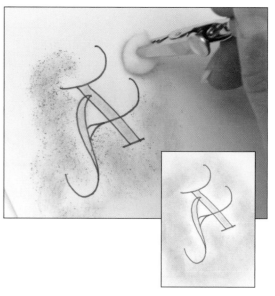

If the chalk extends way outside the letter or you don't like the color, you can erase the chalk with a white eraser.

Another chalking method is to chalk title backgrounds. After creating your title or individual letter on a light colored cardstock, chalk the entire area around your word or letter. This gives your title or letter a soft background and one you can customize

For a more unique look to your title, tear an edge around the word. Begin by chalking a large area around your letter or word. Then, start tearing in a corner holding the outer edge in your right hand and tear the paper towards you. Continue tearing in the same direction all the way around the title. Tear the paper towards you to keep the same rough edge all around the title.

After you have finished tearing your paper, use the same color of chalk on the torn edge of your title, applying this with a pom-pom or cotton ball. The rough edge will accept the chalk more readily thus giving the appearance of dimension.

To add more pizzazz to your title, you can mount it on mulberry paper. Tearing the mulberry paper is a great way to achieve a fuzzy look. Start by adhering your title to the mulberry paper. Then run your water brush on the mulberry paper, around the outside of the title, a bit away from the torn edge of the cardstock.

Running the water brush on the mulberry paper makes the paper easy to pull apart. Pull the mulberry paper apart all the way around your title or letter.

This creates a great mat for your title.

A few additional title tips
When designing a title, I usually only do one or two words in my creative lettering style. The rest are done in script or print. I use a brush marker for script writing and a drawing marker for print if I want to match my colors.

Creative Additions
Lettering is meant to be fun, so enjoy it. Be creative. Add die cuts, stickers, punch art, or little drawings to your letters (note the hearts on the topper below).

Valentines Day Page Topper
by Debra Beagle

ALPHABET: Gloria #12

PENS: Marvy Medallion .03 black and .01 red. Marvy Twinklette, red.

OTHER SUPPLIES: Red mulberry paper.

Shrink It

Make beautiful little letter or word charms for your projects using Shrinky Dinks. Use clear or frosted shrink plastic material just as you use vellum. Create full size titles or letters on the shrink plastic using markers or colored pencils following the techniques presented previously.

You can chalk the plastic as well to change the color of it. Cut your words or titles out, or punch them into shapes. Add a hole at the top with a hole-punch to create a tag. To shrink, follow the instructions provided with the Shrinky Dink product. You can use heat from an oven or a heat gun. Add your new tag charms to your projects.

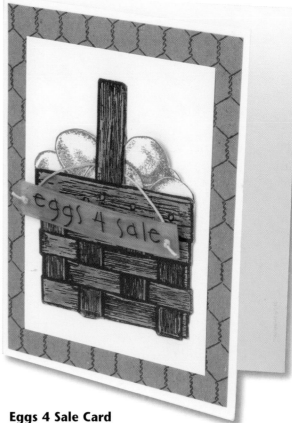

Eggs 4 Sale Card
by Wendy Pannell

ALPHABET: Madison #26 in full size on shrink plastic

PENS: Sharpie, black, by Sanford

OTHER: Basket and egg stamps by River City River Works. Chicken wire stamp by Stampin' Up. Eggs stamped with sepia ink. Brown chalk was used on the back side of shrink plastic.

I Love You Card
by Wendy Pannell

ALPHABET: Bonnie #6

PENS: Marvy Memories Calligraphy, 3.5 nib

OTHER: Cardstock from Club Scrap. Tag stamp by River City River Works. Adirondack ink by Red Pepper. Heart stamp by Stampa Rosa.

Gallery

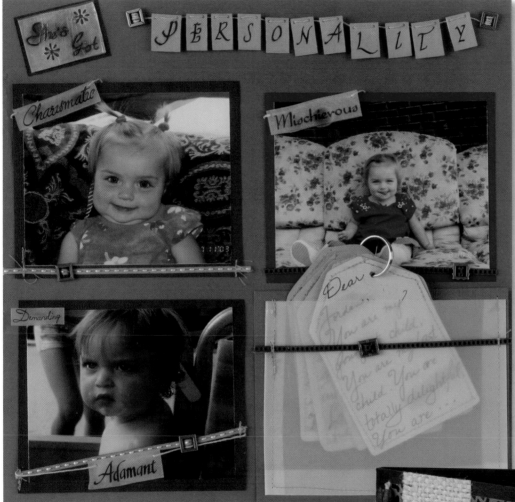

She's Got Personality
by Victoria Bowling

TITLE ALPHABET:
She's Got: Lizbeth #7
Personality: Bonnie #6

CAPTION ALPHABETS:
Charismatic: Linda #10
Demanding: Lourdes #27
Adamant: Bonnie #6
Mischievous: Nicolette #3

PENS: Marvy Artist, black

OTHER SUPPLIES: Shrinky Dinks. Charms by Making Memories. Punch by Carl. Adhesives by Glue Dots.

DESIGNER NOTES: Focusing on the descriptive words made me reflect on my daughter's personality and realize that even though sometimes she's a little stinker, she can be a "melt your heart" charmer, too. Could it be that hand lettering allows you time to slow down and reflect?

Thank You Card
by Wendy Pannell

ALPHABET: Lizbeth #7, freehand with fine black Indenti-Pen

PENS: Marvy Le Plume #90 used for coloring in back of tag.

OTHER: Leopard sticker paper by One Heart, One Mind. Vellum tag by Making Memories. Burlap ribbon by Loose Ends.

DESIGNER NOTES: Horsehair donated by my geldings Whiskey and Partner.

Gallery: Suzette

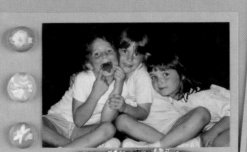

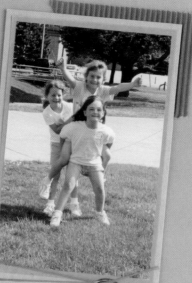

Cheerleading

The trio: *Cami Willman, Andi Ralph, and Stephanie* at their first all day cheerleading camp held Middle Tennessee State University (MTSU) and put on by Alpha Delta Pi sorority. April 2008

Camp

G

four GENER

Cheerleading Camp
by Debra Beagle

ALPHABET: Suzette #11

PENS: Marvy Medallion .03. Marvy Memories Le Plume, denim blue.

OTHER SUPPLIES: Buttons from Making Memories. Adhesive by Glue Dots.

With Love Envelope
by Donna Luncford

ALPHABET: Suzette #11

PENS: Marvy Medallion .05, black

OTHER: Rose stamp by Wordsworth. Black Marvy Memories ink pad. Derwent Artists pencils in geranium lake and mineral green.

DESIGNER NOTES: Envelope was made out of vellum using The Envelopes Please template by Stamp Your Art Out.

Festival of Lights Page Topper
by Debra Beagle

ALPHABET: Suzette #11

PENS: Marvy Medallion, black. Marvy Twinklettes, blue and purple.

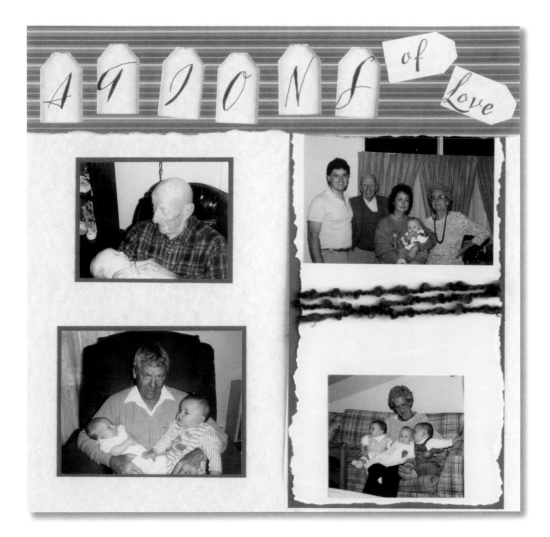

Four Generations of Love
by Christy Kalbhin

ALPHABET: Suzette #11

PENS: Marvy Le Plume II Prussian blue and Marvy Memories Artist, black.

OTHER SUPPLIES: Paper by The Robin's Nest, Parchment by Memories Forever. Tag punch by Whale of a Punch.

DESIGNER NOTES: I wanted the pictures to talk so I put the journaling on pullouts under the navy cardstock. In the past, I probably would have used stickers instead of hand lettering. Hand lettering made the page more personal and more elegant.

Gallery: Gloria

Snow Kittens
by Nancy Walker

ALPHABET: Gloria #12

PENS: Marvy Medallion .03, Marvy Le Plume, steel blue. Schaffer fountain pen with blue ink and a calligraphy nib.

OTHER SUPPLIES: Paper by Club Scrap. Canson watercolor paper. Adhesives by Glue Dots.

DESIGNER NOTES: The alphabet looked like it went well with cold, snowy scenes. Its thin lines look like icicles or ski trails. I love the fill-in hand lettering technique. The titles can be customized to the layout with color and shapes inside.

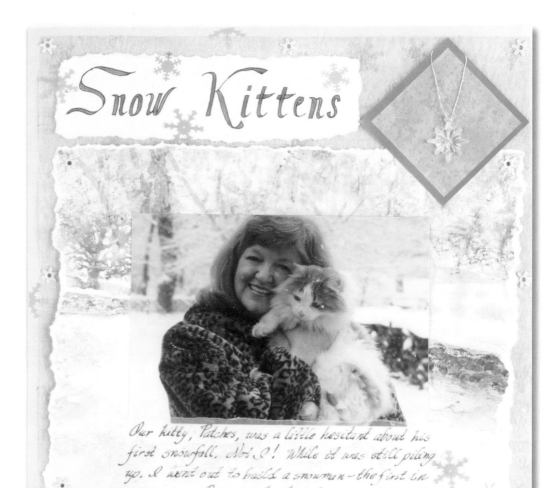

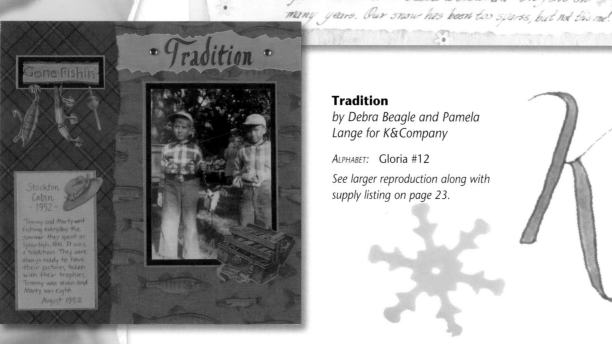

Tradition
by Debra Beagle and Pamela Lange for K&Company

ALPHABET: Gloria #12

See larger reproduction along with supply listing on page 23.

Gallery: Bethany

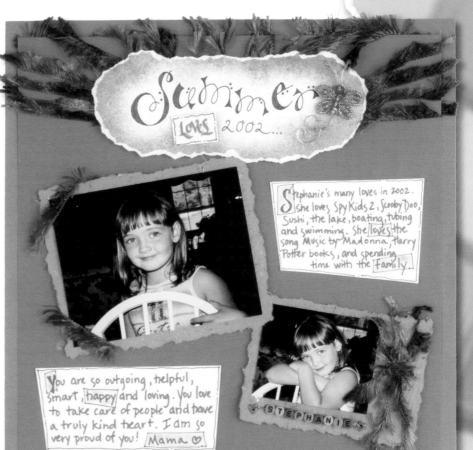

Summer 2002
by Debra Beagle

ALPHABET: Bethany #19

PENS: Marvy Medallion .03, purple. Marvy Twinklette, purple. Marvy Memories Calligraphy, 2.0 nib, orange.

OTHER SUPPLIES: Adhesives by Glue Dots.

DESIGNER NOTES: The orange paper was handmade. I also made the butterfly on the page topper.

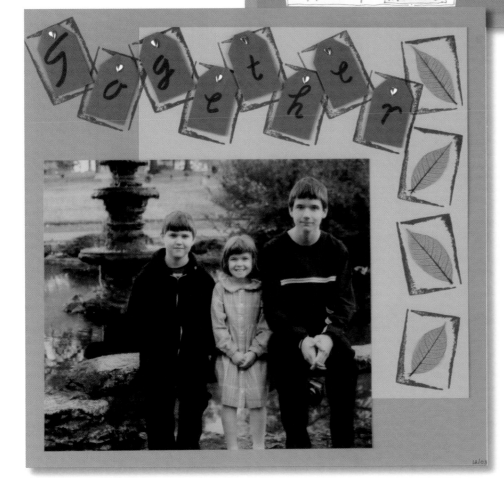

Gallery: Natalia

Together
by Karen Moffatt

ALPHABET: Natalia #23
PENS: Marvy LePlume brush marker, black.

DESIGNER NOTES: This picture was taken in the memorial gardens after my father-in-law's funeral. It is a calm, beautiful place and I was happy to capture the beauty of our children. I wanted something gentle and reverent this alphabet was perfect.

Gallery:
Elena

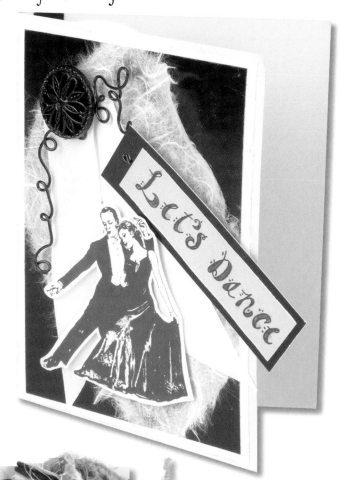

Let's Dance
by Patricia League

ALPHABET: Elena #13 at 60%

PENS: Marvy Le Plume black.
Marvy Twinklettes.

OTHER SUPPLIES: Stamp by
Viva Las Vegas. Vellum by
Close to My Heart.

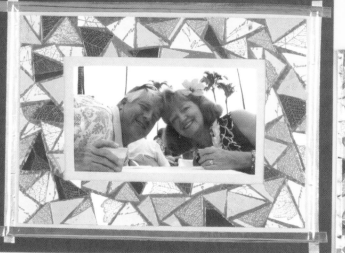

Royal Kona Luau

It's funny how we have
found creative ways to
take pictures of us as
a couple when no one is
there to volunteer for
the duty. At the luau,
the sun was just
setting and the light
was getting just "right",
so we set up the
camera for a timed
shot. We thought if
we scrunched down &
looked into the lens it
would not cut off our
heads. We forgot all
about the camera's large
field of vision!

Say Cheese
by Nancy Walker

ALPHABET: Elena #13

PENS: Marvy Medallion,
black, Marvy Memories Le
Plume, wine.

OTHER SUPPLIES: Copper
brads by Boxer Scrapbook
Productions. Charm by
All About Memories. Suze
Weinberg's Ultra Thick Em-
bossing Enamel by Ranger
Industries. Copper screen
mesh by American Art Clay
Co. Wire by Artistic Wire.
Fibers by Lion Brand. Ad-
hesive by Xyron.

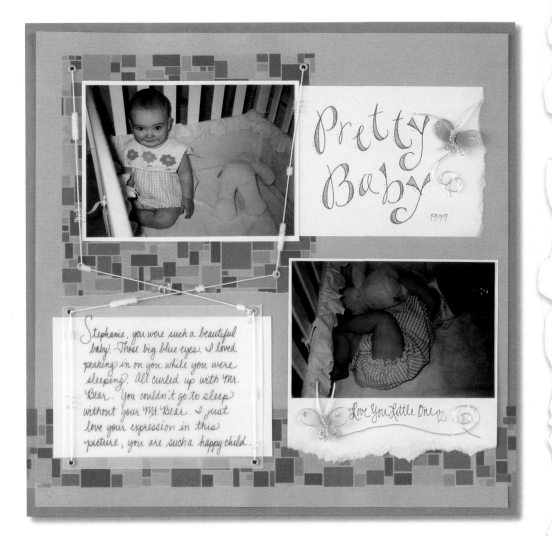

Pretty Baby
by Debra Beagle

TITLE ALPHABET:
Elena #13

PENS: Marvy Medallion 3.0, black. Marvy Twinklette, pink.

Stephanie, you were such a beautiful baby. Those big blue eyes. I loved peaking in on you while you were sleeping. All curled up with Mr. Bear. You couldn't go to sleep without your Mr. Bear. I just love your expression in this picture, you are such a happy child.

Thank You Card
by Victoria Bowling

ALPHABET: Elena #13
PENS: Marvy Memories Le Plume, black and Victorian red.

Gallery: Karina

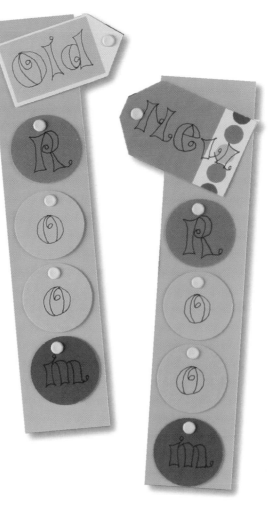

Old Room, New Room
by Karen Moffatt

ALPHABET: Karina #14

PENS: Marvy Medallion .03, black

OTHER SUPPLIES: Paper by SEI. Tags by SEI. Tag punch by EK Success.

DESIGNER NOTES: This layout was based on a book and the alphabet reminded me of the style of that book. With colored stock, the fill in alphabet didn't need to be filled!

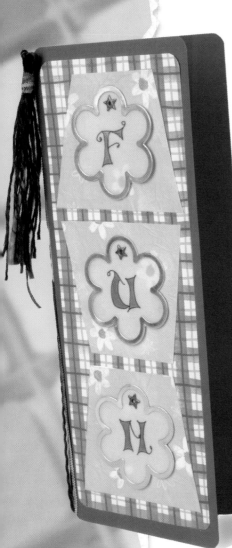

Flower Fun Card
by Laurie Waldron

ALPHABET: Karina #14

PENS: Marvy Medallion, black, Marvy Twinklette, blue.

OTHER SUPPLIES: Vellum daisies by Making Memories. Plaid paper by Karen Foster Designs. Fibers from Angel Hair Yarn Co.

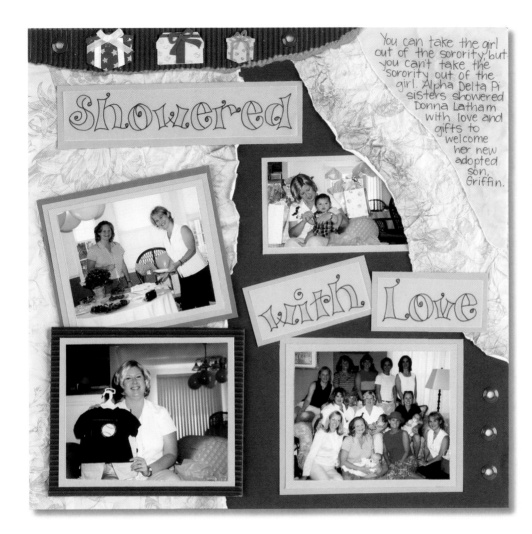

You can take the girl out of the sorority, but you can't take the sorority out of the girl. Alpha Delta Pi sisters showered Donna Latham with love and gifts to welcome her new adopted son, Griffin.

Showered with Love
by Holle Wiktorek

TITLE ALPHABET:
Karina #14

PENS: Marvy Medallion .03, black

OTHER SUPPLIES: Paper by Anna Griffin, DMD Industries and Paper Reflections. Stickers by Jolees By You. Eyelets by Creative Impressions. Chalklets by EK Success.

DESIGNERS NOTES: The whimsical style of the lettering showed the laughter dancing in our eyes and the happiness we were celebrating.

Mardi Gras Card
by Wendy Pannell

ALPHABET: Karina #14 reduced 66%

PENS: Glitter pens

OTHER SUPPLIES: Fireworks stamp by Club Scrap, stamped with Versamark pad. Marvy matchable dye inks sponged over stamped images. Mask hand drawn and cut out of glitter papers, embellished with sequins and jewels.

DESIGNER NOTES: Green feathers donated by my parrot, Peanut.

Gallery: Christy

Easter Fun
by Debra Beagle

TITLE ALPHABET:
Karina #14

PENS: Marvy Medallion 3.0, pink. Marvy Twinklette, pink. Marvy Memories Le Plume, fine tip, green.

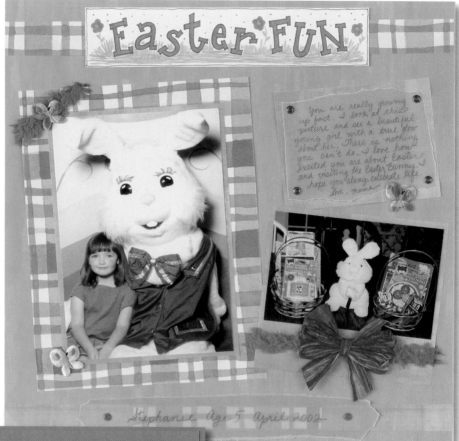

Hikin'
by Victoria Bowling

TITLE ALPHABET:
Christy #16

PENS: Marvy Medallion .03 black.

OTHER SUPPLIES: Pencils by Prismacolor. Deckle scissors by Fiskars. Wire by Artistic Wire. Adhesive by Glue Dots.

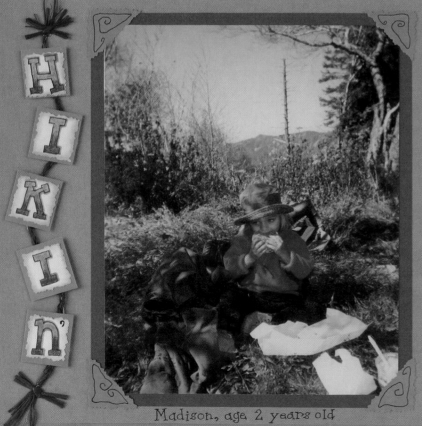

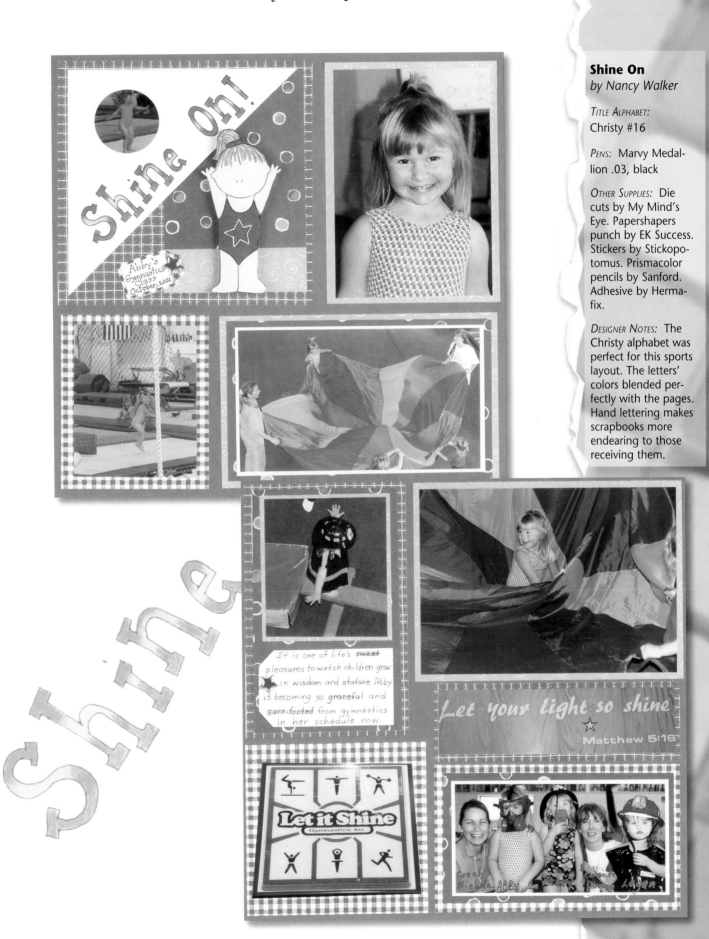

Shine On
by Nancy Walker

TITLE ALPHABET:
Christy #16

PENS: Marvy Medallion .03, black

OTHER SUPPLIES: Die cuts by My Mind's Eye. Papershapers punch by EK Success. Stickers by Stickopotomus. Prismacolor pencils by Sanford. Adhesive by Hermafix.

DESIGNER NOTES: The Christy alphabet was perfect for this sports layout. The letters' colors blended perfectly with the pages. Hand lettering makes scrapbooks more endearing to those receiving them.

Gallery: Isabel

Swing Into Spring
by Karen Moffatt

ALPHABET: Isabel #17

PENS: Marvy Medallion, black

OTHER SUPPLIES: Paper by Autumn Leaves and K&Company. Glitter by Magic Scraps.

DESIGNER NOTES: This alphabet just begged to be embellished. Glitter was perfect for this layout.

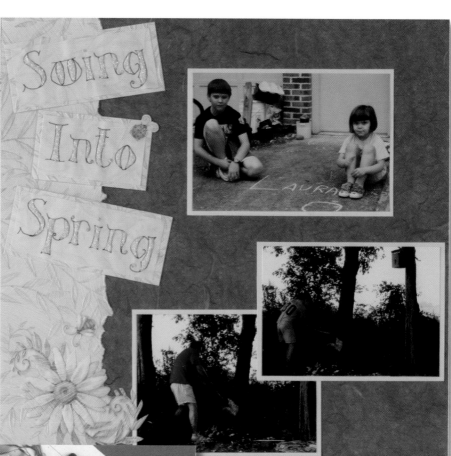

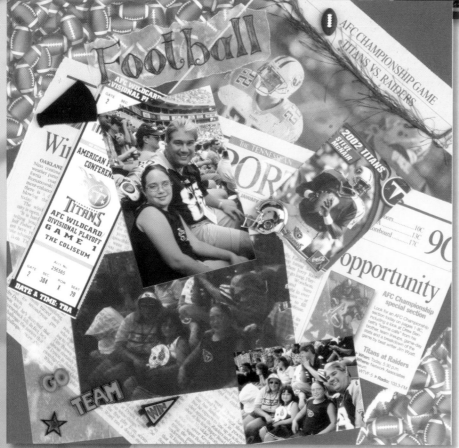

Football
by Kate Childers

ALPHABET: Isabel #17

PENS: Marvy Medallion .05, black

OTHER SUPPLIES: Paper by Bazzill Basics. Vellum by Hot Off the Press. Football corners by Jolee. Fibers are Fun Fur by Lion Brand Yarn. Watercolor pencil by Prisma.

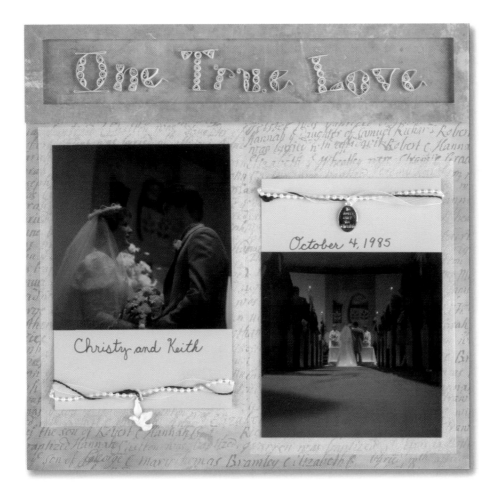

One True Love
by Christy Kalbhin

Title Alphabet:
Isabel #17

Pens: Marvy Artist #65 Cherry

Other Supplies: Paper by Karen Foster Design. Charms by The Card Connection. Pearls by Hirschberg Schutz & Co. Sheer ribbon by Offray.

Designer Notes: Quillery was a unique way to fill in this alphabet. It gave the lettering the texture of wedding lace.

Joy Card
by Wendy Pannell

Alphabet: Isabel #17

Pens: Zig embossing writer embossed with gold detail embossing powder.

Other Supplies: Paper by Paper Adventures. Snowflake stamp by Magenta. Gold embossing powder by Ranger Industries.

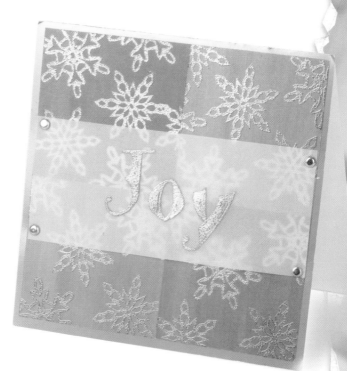

Gallery: Catalina

Cirque de la Mere
by Kelly Milligan

TITLE ALPHABET:
Catalina #15

PENS: Marvy Medallion .03, black

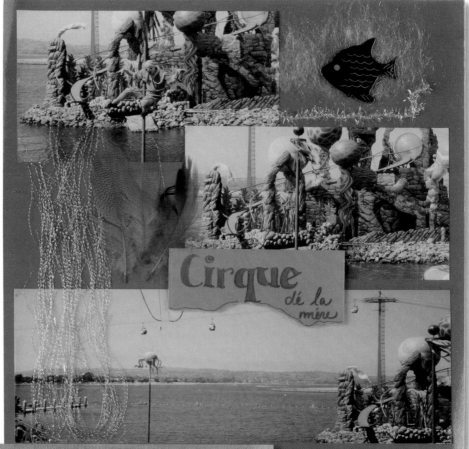

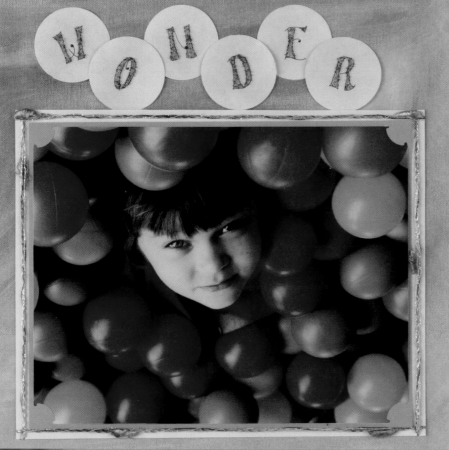

Wonder
Karen Moffatt

TITLE ALPHABET:
Catalina #15

PENS: Marvy Medallion .03, black

OTHER SUPPLIES: Paper by Karen Foster. Microbeads by Magic Scraps.

DESIGNER NOTES: I needed an alphabet that was soft and whimsical. This one was easy to draw and I loved the opening that gave me the option to fill the space with microbeads.

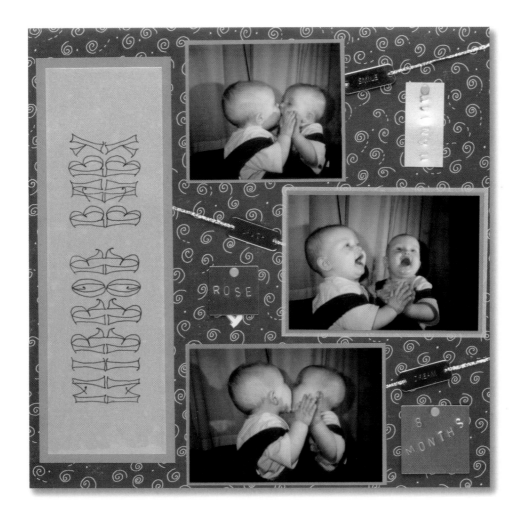

Mirror Baby
by Christy Kalbhin

ALPHABET: Catalina #15

PENS: Marvy Medallion .03, black

OTHER SUPPLIES: Navy spiral paper by Ever After. Pink paper by Close to My Heart. Silver vellum from Creative Paper. Metal stamps by Foufoula. Metal squares by Making Memories. Rivets by Creative Paper.

DESIGNER NOTES: Hand lettering on vellum made it easy to mirror the title. My own handwriting never would have matched and stickers wouldn't have worked to make the mirrored look.

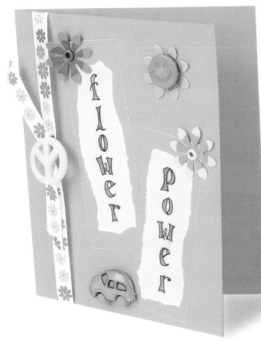

Flower Power
by Patricia League

ALPHABET: Catalina #15 reduced 50%

PENS: Marvy Memories Le Plume, black. Marvy Twinklettes.

OTHER SUPPLIES: Flower punch by Marvy. Marvy Matchable inks.

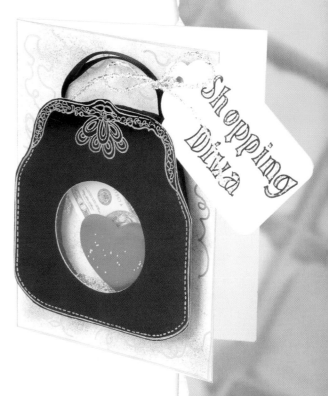

Shopping Diva
by Marilla Naron

ALPHABET: Catalina #15 reduced 50%

PENS: Marvy Twinklette, silver.

OTHER SUPPLIES: Stamp by Me & Carrie Lou. Marvy black and silver ink. Play money and tiny marbles.

Gallery:
Catalina

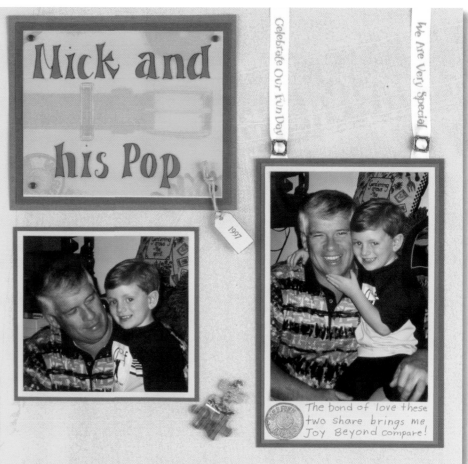

Nick and his Pop
by Nancy Walker

TITLE ALPHABET:
Catalina #15

PENS: Marvy Medallion .03, black; Marvy Memories Le Plume, Prussian blue.

OTHER SUPPLIES: Stamps by Making Memories, Stampendous and Club Scrap. Punch by McGill. Brads by Boxer Scrapbooks. Tiny buckles by Dritz. Adhesive by Glue Dots.

DESIGNER NOTES: Filling in the vellum title from the back side gives a soft, smooth finish. This alphabet emphasizes the fun side of life with my "boys."

Style Card
by Patricia League

ALPHABET: Catalina #15 reduced 50%

PENS: Marvy Memories Le Plume, black. Marvy Twinklette, grey.

OTHER SUPPLIES: Vellum by Close to My Heart. Opera coat stamp by Hero & Co. Black ink by Memories. Glamour net, satin ribbon, black button and feather.

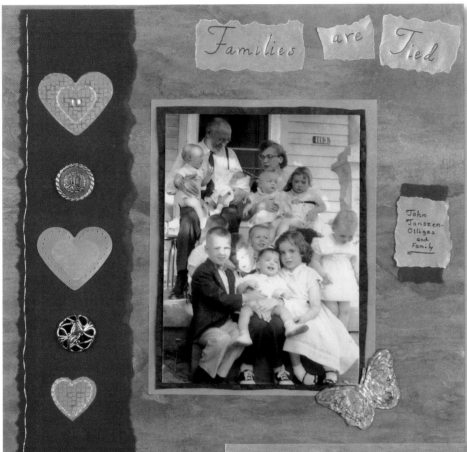

Gallery: Liliana

Families are Tied Together with Heartstrings
by Christy Kalbhin

TITLE ALPHABET:
Liliana #28

PENS: Slick writer, fine black by American Crafts.

DESIGNER NOTES: I copied the letters on tracing paper and embossed them onto the vellum, then traced them with a pen.

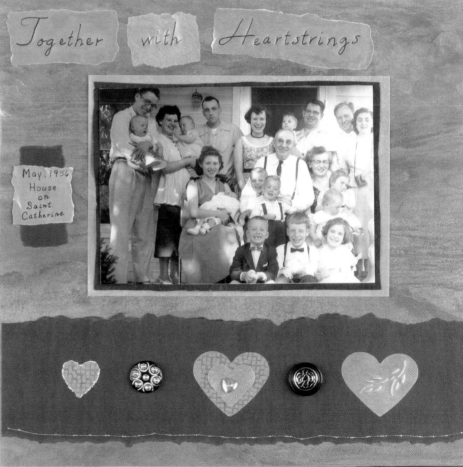

Nature Card
by Donna Luncford

ALPHABET: Liliana #28

PENS: Marvy Fine Line DecoColor.

Gallery: Kaitlyn

Mama and Me
by Holle Wiktorek

TITLE ALPHABET:
Kaitlyn #24

PENS: Marvy Medallion, Marvy Memories Artist

OTHER SUPPLIES: Cardstock by DMD. Build a Page papers and Chalklets by EK Success. Adhesive is Peel n Stick Zots by ThermoWeb.

DESIGNER NOTES: Using my own handwriting in family layouts is like writing a letter to a family member.

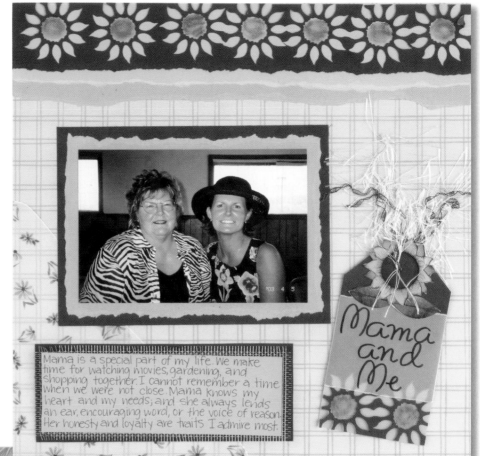

Mama is a special part of my life. We make time for watching movies, gardening, and shopping together. I cannot remember a time when we were not close. Mama knows my heart and my needs; and she always lends an ear, encouraging word, or the voice of reason. Her honesty and loyalty are traits I admire most.

Mama and Me

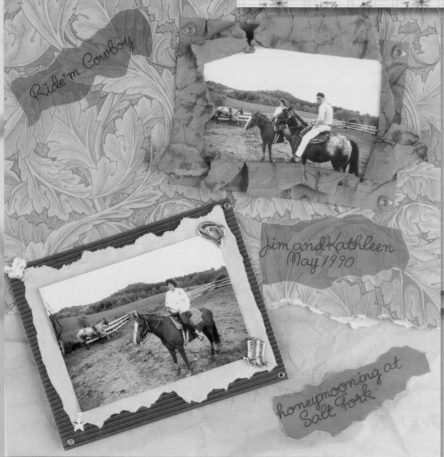

Ride 'm Cowboy

Jim and Kathleen May 1990

honeymooning at Salt Fork

Ride 'Em Cowboy
by Kate Childers

ALPHABET: Kaitlyn #24 reduced 50%

PENS: Marvy Medallion .05, black.

OTHER SUPPLIES: Paper by K&Company. Vellum by Bazzill Basics. Heart eyelets by Stamp Doctor. Chalks by Stamping Up.

Pumpkin Patch

Pumpkin Patch Tag
by Kate Childers

ALPHABET: Kaitlyn #24 reduced 50%

Gallery: Nanci

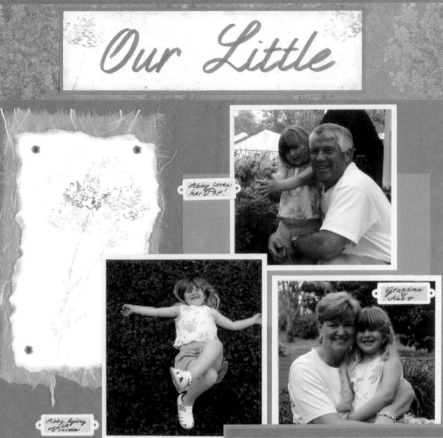

Our Little Flower Child
by Nancy Walker

TITLE ALPHABET:
Nanci #22

PENS: Marvy Memories Le Plume,
jungle green and violet

OTHER SUPPLIES: Watercolor paper
by Canson. Nameplate die cuts
by Quickutz. Stamps by Hero
Arts, Nema Ink and Club Scrap.
Punch by EK Success.

DESIGNER NOTES: This alphabet was
easy to duplicate in the journal-
ing. It coordinated with my
handwriting, too.

Gallery:
Jordan

Bee Happy Card
by Patricia League

ALPHABET: Jordan #25
reduced 50%

PENS: Marvy Medallion

OTHER SUPPLIES: Gold
glitter paint by Amos.

Shogun
by Kate Childers

TITLE ALPHABET:
Jordan #25

PENS: Marvy Medal-
lion .05, black

OTHER SUPPLIES: Card
stock by DMD. Gold
paper by Emagina-
tion. China stickers
by Jolee. Origami
paper by Aitoh.

DESIGNER NOTES: I en-
larged the Jordan al-
phabet 110% for the
title and reduced it
45% for the caption.

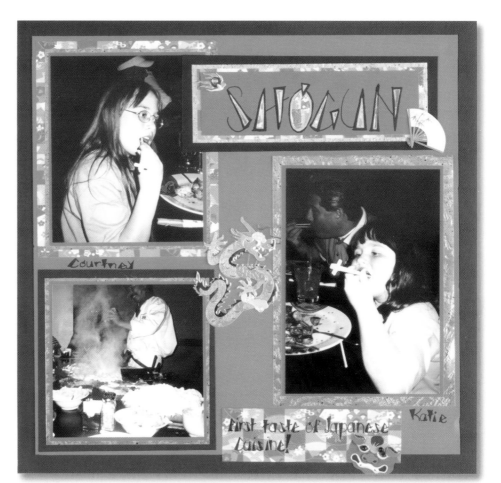

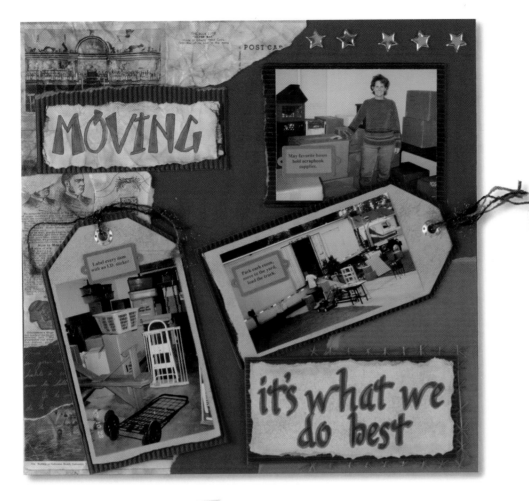

Moving—It's What We Do Best
by Holle Wiktorek

TITLE ALPHABET: Jordan #25

PENS: Marvy Medallion, Marvy Memories Artist and Calligraphy.

OTHER SUPPLIES: Card-stock and collage papers by DMD. Zots adhesive by ThermoWeb. Vintage Toile by Finders Keepers. Die cuts by Quickutz. Chalklets by EK Success.

DESIGNER NOTES: Outlining the titles make them pop off the title blocks.

Envelope
by Wendy Pannell

ALPHABET: Jordan #25 reduced 50%

PENS: Marvy Medallion .03, blue

OTHER SUPPLIES: Marvy Matchables ink, blue. Stamp by Stampin' Up. Design applied with small rubber brayer.

Vacation in a Box Card
by Marilla Naron

ALPHABET: Jordan #25 reduced 50%

PENS: Marvy Medallion, black.

OTHER SUPPLIES: Shell stamp by Hero & Co. Box stamp by Inky Antics.

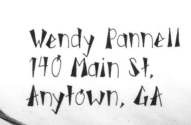

Gallery: Madison

First Day of Kindergarten
by Debra Beagle

TITLE ALPHABET:
Madison #26

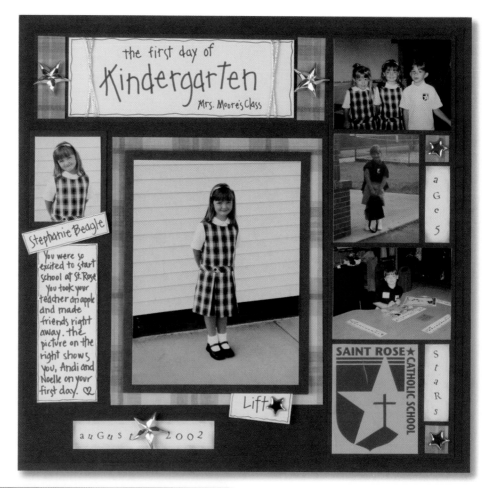

First Day of School
by Victoria Bowling and Madison Bowling

TITLE ALPHABET: Madison #26

PENS: Marvy Memories Artist, red

OTHER: School charms by The Card Connection. Chalkboard by Darice. School Days by Rebecca Sower for EK Success. Eyelets by Making Memories. Red fiber by Adornments.

DESIGNER NOTES: My daughter Madison wrote the title lettering herself using Debra's alphabet (named after her!). Madison was is 5 years old when she helped with this layout. She was so careful and so proud of herself. She even wrote her name on the chalkboard and the year.

You are never too young to create beautiful writing. If a rambunctious child can have the patience to try this, you can, too!

GAMES WE PLAY

Gallery: Angelique

October 2001

Mary Love

Our Leader, Fred

Freehand Freedom

Alphabets with no straight lines and all curves are easier to try freehand. Curves give room for lots of freedom and do not show mistakes.

Like family~that's how our small group feels about each other. Our first retreat together at Fairfield Glade was all play~cards, golf, tall tales, great food, & laughter~embraced by autumn's crisp air.

Small Group Retreat

Jim

Linn

Jane

Ron

Nancy, Gayle, & Nancy

Sally

L to R: Mary Love, Jim, Linn, Sally, David, Janie, June, Tom, Nancy, & Edd. Front: Gayle, Fred, Dick & Nancy

Games We Play
by Nancy Walker

TITLE ALPHABET: Angelique #18

PENS: Marvy Medallion, black, Marvy Memories Le Plume, black and Marvy Twinklette. Fiskars, silver.

OTHER: Paper and embellishments from Club Scrap. Double spiral clips by Making Memories. Silver studs and mirrors by JewelCraft. Spirale easel and cameo spirale by 7Gypsies. Card embellishments by Westrim. Metal adhesive by Making Memories. Other adhesive by Hermafix, Pioneer and Glue Dots.

DESIGNER NOTES: The lettering coordinates with the diamonds and circles on the printed paper. The lettering style is very versatile and easy to copy to a smaller size by just looking at the example and drawing it to scale.

Gallery: Angelique

Princess Party
by Victoria Bowling

TITLE ALPHABET:
Angelique #18 and
Victoria #5

PENS: Marvy Medallion .03 black. Marvy Twinklette, pink. Marvy embossing pen.

OTHER SUPPLIES: Paper by Paper Adventures. Patterned vellum by Paper Pizazz. Star eyelets by Making Memories.

DESIGNER NOTES: I wanted this layout to have a royal feeling and the lettering gave it just the right regal touch.

Fall Tag
by Kate Childers

TITLE ALPHABET:
Angelique #18

PENS: Marvy Medallion .05, black

OTHER SUPPLIES: Handmade paper and serendipity squares created by Kate. Letters were filled in with gem tac liquid and micro beads were added.

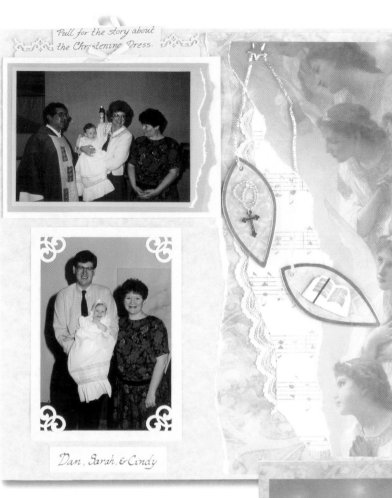

Pull for the story about the Christening Dress.

Dan, Sarah, & Cindy

Pull for the story about the Christening Dress.

When Sarah was born I knew I was destined to make her Christening gown. So I went to work on the project after picking out the pattern, buying all the entredeaux and lace and mother of pearl buttons. The cost for all was about $75. French hand sewing is not inexpensive, but I hoped the dress would someday become an heirloom, lovingly made!

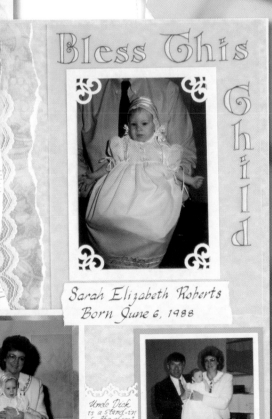

Bless This Child

Sarah Elizabeth Roberts Born June 6, 1988

Aunt Nancy is Godmother ~

Uncle Dick is a stand-in for the absent godfather ~

Bless This Child
by Nancy Walker

TITLE ALPHABET:
Angelique #18

PENS: Marvy Medallion .05, black. Schaeffer calligraphy pen, black.

OTHER SUPPLIES: Sonnets paper by Creative Imaginations. Card stock by DMD Industries. Tags are Sharon Soneff Sonnets by Creative Imaginations. Lace punch by Fiskars. Corner punches by EK Success. Ribbon by Offray. White pencil by Sanford. Adhesive by Glue Dots and Hermafix. Foam tape from 3M.

DESIGNER NOTES: The Angelique alphabet was great for a religious theme. It added to the old lace and Christening theme. After outlining the letters in black, I turned the vellum over and dry embossed the fill-in areas. I added white pencil to further enhance the whitened areas on the vellum.

Decorative Lettering

*N*ow it's time to see how you can apply your new found lettering skills to plastic, fabric, wood, glass and walls.

First, select an alphabet that you would like to use from the back of the book and choose a name, word or title for your project. Follow the techniques learned in the previous chapters to write your title on vellum. You can also add flowers. Now you are ready to begin transferring the word to any project.

Plastic Tote Using Paint Markers

The Marvy DecoPaint markers work best on plastic. Take the title you just created and tape it to the inside of the object on which you would like to write the lettering. You may want to use a plastic pencil holder or any kind of plastic tote.

around mixing the paint so that the ink will flow when you use the pen. Take the cap off and, on a scratch piece of paper, depress the tip of the pen. This pushes the nylon up into the pen and allows the ink to flow down into the tip. This may take several repetitions to get the ink going. When it's ready to use, you will see the paint begin to flow out of the marker.

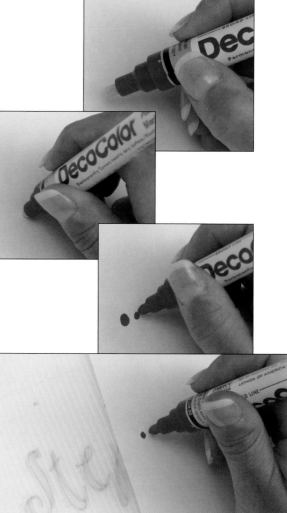

Select the paint pen you would like to use. I am using a Marvy DecoColor crimson red in a broad point tip for this project. Shake well with the cap on, tip up. You will hear the ball inside moving

Now, trace the word you have taped inside the tote.

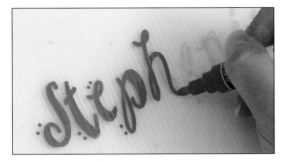

You can also add dots around the word as embellishments.

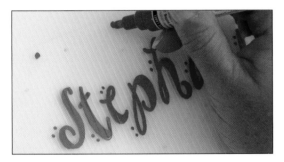

Trace the flower using a broad tip blue paint marker and add the leaves and vine using the green paint marker.

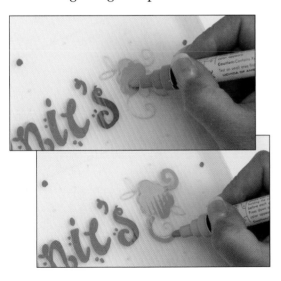

Allow the colors to dry before adding another color. Add white to the center of the flowers and white dots to the inside of the letters. Maintain the positioning of the dots from letter to letter along an invisible guideline for continuity. When

using white over another color you may need to go back over the white several times before it is opaque.

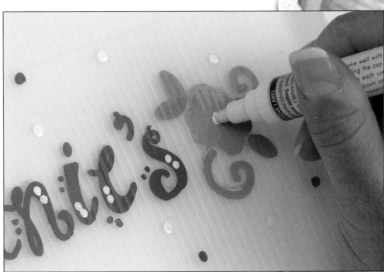

Stephanie Craft Tote
by Debra Beagle

ALPHABET: Elena #13

PENS: Marvy DecoColor

OTHER SUPPLIES: Plastic tote by Cut It Up. (The flower design on the tote that appears on the Contents page also by Cut It Up.)

Fabric Markers

A handmade gift makes any party or shower special. You can use the following technique to create design shirts for a birthday outing or to make a special apron for a bride-to-be.

To create fabric lettering, first select what you would like to write and the alphabet you would like to use. Then create the lettering on vellum following the technique outlined in previous chapters.

Next, place the vellum underneath a light colored shirt or apron. When working on fabric it is best to use vellum because it is not porous. When you use markers on the fabric the vellum tends to minimize paint bleed. I also used a light box to help see the word through the fabric.

Glowing Gifts

You can also use a glow in the dark fabric marker to add a little fun to your project. This is a project that kids can do, too.

Trace the word you have taped under the apron or piece of fabric.

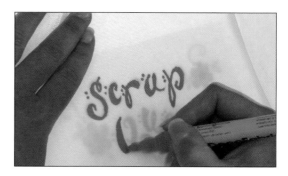

Trace the flowers using a blue fabric paint marker and add the leaves and vine using the green paint marker.

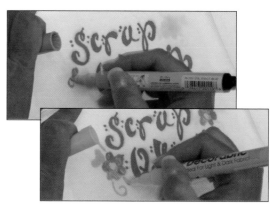

Allow colors to dry between colors. Add yellow to the center of the flowers. When using yellow over another color you may need to go back over the yellow several times before it is opaque.

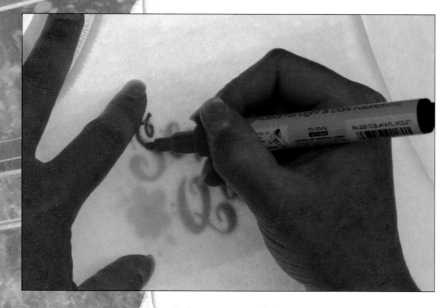

Select your fabric paint marker and colors and get the ink flowing just as you did with the paint marker on page 74. I am using a Marvy DecoFabric violet marker for this project.

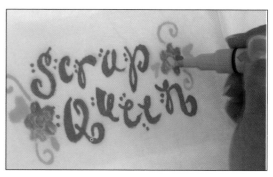

gallery

Baby Jordan Bib
by Debra Beagle

ALPHABET: Bethany #19

PENS: Marvy Deco-Fabric

OTHER SUPPLIES: Fabric bib

Scrap Queen Apron
by Debra Beagle

ALPHABET: Elena #13

PENS: Marvy DecoFabric markers

OTHER SUPPLIES: Apron or T-shirt

Brian's 1st Birthday Bib
by Debra Beagle

ALPHABET: Mackenzie #21

PENS: Marvy Deco-Fabric

OTHER SUPPLIES: Fabric bib

gallery

Nature Tote
by Donna Luncford

TITLE ALPHABET: Liliana #28

PENS: Marvy DecoColor, black fine line

OTHER SUPPLIES: Jacquard Acrylic Fabric Pains. Pine cone stamps by Stampin' Up.

DESIGNER NOTES: The Liliana alphabet was the best one for use with the Fine Line Deco-Color pen. It was also easy to free hand.

Lunch Boxes
by Debra Beagle

TITLE ALPHABETS: Courtney #20

PENS: Marvy Deco-Color

OTHER SUPPLIES: Lunch boxes

Scrapbooking Pencil Holder
by Debra Beagle

TITLE ALPHABETS: Elena #13

PENS: Marvy DecoColor Markers

Painting Letters

The technique that you have learned can also be used to letter on wood, ceramic and clay.

For a project such as the yard sign below, start with a painted surface (an unfired piece of ceramic or a clay pot also works using this technique). Other supplies that you'll need are graphite transfer paper (available at craft or scrapbook stores), a stylus and your word and image drawn on paper or vellum.

Position your word and image on the board where you would like it. Lay a piece of graphite paper underneath the word (making sure the graphite side is facing down). Trace over the word with your stylus. By doing this, you are transferring the graphite to the wood board where your letters are.

Once you have finished transferring with the stylus, you can remove all of the papers and your word should appear on the wood board. The word is now ready to be colored in. Use a paint marker like the Marvy DecoPaint Markers. Apply a spray sealer if the object will be displayed outside. (On unfired ceramics, color in the letters with the Cerama-Color paint makers. On clay pottery, try the Garden Craft paint markers.)

Painting on Walls

Transferring your lettering to walls is easy using a projector. Projectors can be purchased at art and craft stores. You can use your projector to enlarge images or words on a wall or poster.

Start by cleaning or painting the wall on which you want to letter. Create your words and images on paper or vellum. Position your design under the projector. Turn the projector on and display your word on the wall.

Adjust the projector for size and placement of the design. Outline the words and images on the wall with the broad tip DecoColor marker color of your choice. Once you have finished outlining the word, color it in using the Deco-Color marker. You can also use a paint brush and a traditional acrylic paint.

The Garden Shack Yard Sign
by Linda Beagle

TITLE ALPHABET: Holle #2

PENS: Marvy Deco-Color Paint Markers

Your Handwriting

Recently I came across a rare letter that my grandmother had written to my grandfather while living in Cuba back in the mid 1900s. Words cannot describe the excitement I felt in finding this treasure. Even though the paper had aged some, and the edges were a bit tattered, the letter was written in a beautiful script. To read her words and thoughts, in her own handwriting—misspelled words and all—was a true gift. I was able to see a part of her personality through her handwriting.

My maternal grandparents, Catalina and Manolo Amandi, circ. 1944, Havana, Cuba.

Of all the ways we express ourselves, none is quite so personal as our handwriting—so personal and important that our signatures are legally protected as a mark of identity. Our handwriting is a part of us, a small window into who we are.

As I travel across the country teaching lettering, the question I ask students most is, "Would you like to improve your handwriting?"

Hands always rise high in the air and I hear a resounding *yes*. When asked why? Many answer "I want my handwriting to look better… or be more readable…or be good enough to be proud of, or to reflect another part of me in my scrapbooks."

Most of us *do* care about our handwriting. Yet handwriting has been largely discarded in school subjects and many use computers for their writing. It has become less likely that people learn the basic principles. Here are some helpful steps to follow.

Step 1: The first step to improving your handwriting is to decide that it *does* matter.

Step 2: Mold your handwriting into a rhythmic, coherent, unified whole. By doing this you will be creating beautiful handwriting. Think about computer fonts you may have. Even the most simple print font is attractive because when created by the computer it is rhythmic and unified.

How can you do this? Consistency is the key. *Control the consistency of the slant and proportions of your letters and your handwriting will improve.*

Controlling Your Slant

First, decide on a slant (an angle relative to vertical). Then, use the slant consistently without deviation for all your letters. This gives your handwriting a beautiful rhythm. More than any other aspect, consistent slant will give your writing coherence and unity.

It doesn't really matter what angle you choose, just choose one that feels comfortable to you. Handwriting analysis shows that slant can convey a message, or part of your personality. A slight forward slant conveys energy and measured forward action. A backward slant conveys caution, a conservative pace. An extreme forward slant conveys eagerness, or perhaps a bit of recklessness. Perfectly vertical writing conveys formality.

Controlling Proportions

There are several proportions you need to consider. First, decide on a proportional space to leave between words (the width of the letter o is one possible choice). Then use that proportional spacing consistently.

Decide on the size relationship between short and tall letters, and use that relationship consistently.

Decide on how far down the descenders will drop relative to the tall letters and the short letters, and use that relationship consistently.

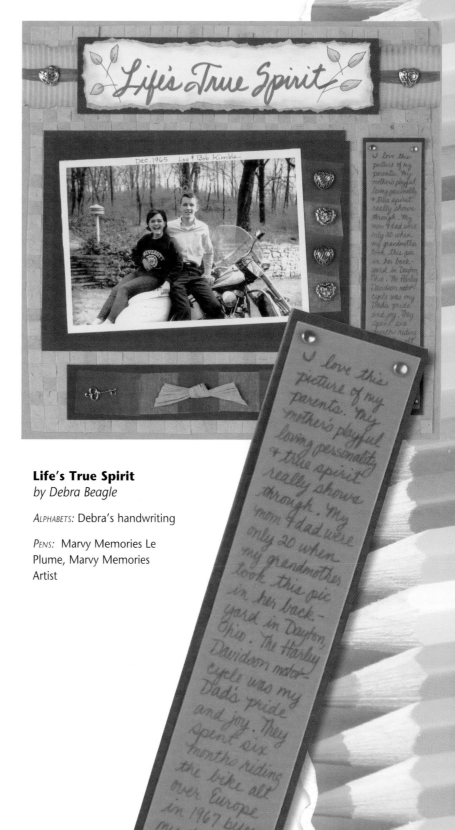

Life's True Spirit
by Debra Beagle

ALPHABETS: Debra's handwriting

PENS: Marvy Memories Le Plume, Marvy Memories Artist

Using Graph Paper

Controlling proportions in your handwriting becomes even easier when using vellum and graph paper. (Light colored paper over graph paper on a light box is also an option). Place a sheet of graph paper underneath the sheet of vellum you wish to journal on.

Journaling and writing can be easy when you use graph paper. By simply setting proportions for your writing you have created a rhythm and continuity which improves the appearance and legibility.

When you are finished with your journaling, remove the graph paper from behind the vellum and your journaling is done. No need to erase guidelines!

The blocks of the graph paper can be used to set and control the size and spacing of your letters and words. Each letter body takes up one box on the graph paper, capital letters and ascenders take up the body box and one vertical box above. Descenders take up the body box and one vertical box below.

When going on to the next line, skip a row of boxes between your main line and the upper line of your capital letters.

When journaling, pen selection should also be a consideration. Chose one that fits your style. A heavy, dark line, for example, conveys power and muscular or intellectual strength. A thin, fine, precise line conveys a fine sensibility and elegance. A medium line that varies in width (from a flexible pen point like a brush tip marker) conveys an aesthetic personality. A wide, sturdy line conveys a rugged, natural personality.

Gallery

WELCOME

:Your Grandmothers comforting you, soothing your first cries.

finding out I was pregnant at only two weeks, meant a long nine months

Breathe Dad, I won't break, even though I am barely a handful

to the WORLD

:You were so small, but perfect. Our son, finally in my arms, and my heart.

Welcome to the World
by Christy Kalbhin

TITLE ALPHABETS: Elena #13 plus Christy's own handwriting

PENS: Marvy Memories Artist #100 sapphire; Slick Writer, blue fine point

OTHER SUPPLIES: Paper by Colorbok.

DESIGNER NOTES: Using an X-acto knife, I cut out the spaces in the letters to let the background paper show through.

Other Lettering

This book would not be complete without mentioning other forms of lettering you can use in your projects.

Lettering Templates

Lettering templates can make lettering easy. Using templates for lettering can be made even easier by using graph paper under your vellum or cardstock.

A fun technique with templates is to do a word in a word (see example below). Lay your cardstock over graph paper and on top of a light box. Write in script, all lower case letters, the word *summer* using a .03 drawing marker (use the graph paper boxes for your guideline and spacing). Then use a template to create the word *FUN* over top of the word *summer*. Using the .03 drawing marker, outline the *U* over the middle of *summer*, stopping as you get closer to the word *summer* when outlining the *U*. Then repeat this with the *F* and then the *N*. You can then color in the *FUN* with chalks.

Creative Lettering CDs

Computer lettering can be used effectively along with your hand lettering. Popular lettering CDs include those from Creating Keepsakes, DJ Inkers and Chatterbox. You can load these onto your computer and access them through the font list in your word processor (I use Microsoft Word). You can make great letters and titles any size, print them out on vellum or cardstock, and then color them in following techniques outlined in this book for that handmade look. Computer journaling is also useful if you're trying to fit a lot of journaling into a small space.

Downloadable Fonts

In addition to lettering CDs, thousands of fonts are available online for free and for sale. Some of my favorite sites for downloading fonts are www.twopeasinabucket.com and www.p-22foundry.com.

A question I am asked often is, "How do I download fonts and then get the fonts into my word processing program so I can use them?"

How to Download Fonts

A very dear friend of mine, Angie Pedersen, has the ultimate font site and font tutorial. Every time I download a font I pull out this help sheet. Angie graciously allowed me to reproduce the information here so you would have all of your lettering resources in one book.

JULY FUN summer 2003

Courtesy of www.onescrappysite.com:

Make a Folder Just for Fonts

Creating a folder on your computer just for font downloads makes it much easier to find the files after you've downloaded them. You can also download a bunch at a time, then unzip and install them at your leisure (very necessary for font addicts!).

To create a new folder:

1. Double-click on "My Computer" on the desktop.
2. Double-click on the "(C:)" drive.
3. Choose *File* from the Menu Bar and scroll to *New*. Choose *Folder* (File: New: Folder)
4. The words "New Folder" will be in blue. Type in the name of what you choose the new folder to be. I named mine "Fonts."

5. Hit *Enter*. You now have a folder on your computer where you can save your fonts—and find them again!

I Found a Cool Font—Now What?

1. Click on the graphic for the font you want to download (such as Blacklight on the B's page: www.onescrappysite.com/fonts/sbfontsb2.htm). The download should start automatically.
2. A gray screen will open called "File Download." It says, "You have chosen to download a file from this location," and asks you, "What would you like to do with this file?" Your two choices are: "Open this file from this location" and "Save this file to disk." Click the radio button (little black circle) next to "Save it to disk". Then click *OK*.

She Can Name That Font in 3 Letters!

In addition to a great font tutorial, Angie Pedersen's onescrappysite offers many free fonts for downloading and other great resources for crafters and craft teachers.

3. Then a window will appear, called "Save As." Choose the directory where you want to save the zipped font file, such as the new folder we created in the first section. Click the drop-down menu at the top of the "Save as" screen. Choose (C:). Then double-click the folder where you want the font file saved.

4. The "Blacklight" file name should be in the "file name" bar near the bottom. Click *Save*.

5. Then your computer will start the saving process. Click *OK* to close the download window. Congratulations, you just downloaded something! Now, to find it again...

Unzipping a File & Installing a Font

1. Go to your desktop and double-click "My Computer".

2. Double-click "(C:)" drive.

3. Double-click the "Fonts" folder you just created. The zipped "Blacklight" file should be inside the folder.

4. Double-click the "Blacklight" zip icon (a file folder with a c-clamp on it) to "unzip" it. (*Note*: You *must* have an "unzipping" utility, such as WinZip, to unzip the fonts on pretty much all font sites. You can download it here: http://www.winzip.com/download.htm.)

a. Double-clicking on the file folder with a c-clamp on it will bring up the "Thank You for Trying WinZip" window. Click on "I Agree".

b. This will "unzip" the file, and bring up a screen called "WinZip (Unregistered) – filename.zip". In the white part of the window is the font file. Keep this window open.

5. Click on the Windows *Start* button at the lower left hand corner of your screen.

6. Choose *Settings*

7. Choose *Control Panel*.

8. Double-click on *Fonts*. Keep this window open (you can close the Control Panel window). Click on the WinZip window again. Drag the font icon (with the gray & blue "T's" on it) onto the Fonts window. That will install it. Now the font should be available in all your Windows programs. Sometimes, however, you may need to "reboot" your computer before a font will show up. (This means turn it off, and turn it back on again.) Try this before despairing!

Printing a Mirror Image

Many scrappers love being able to print fonts right out from their computer, trim it to size, and slap it on their page. But you can also have your computer reverse your font title so it's a mirror image, and print it onto cardstock. When you cut out the letters, the outline is on the back of your title! No lines to erase!

1. Open Word to a new blank document.

2. Choose *Insert* from the top menu bar.

3. Choose *Picture: WordArt*.

4. Choose the style of WordArt you want for your project.

5. Type in your title. Hit *OK*. Resize your title by dragging on the white boxes at the corner of your WordArt. You can also drag the title to any location on the page.

6. Choose *View* from the menu bar at the top of the screen. Choose *Toolbars: Drawing*. The Drawing toolbar will appear at the bottom of the workspace.

7. Choose *Draw* from the Drawing toolbar, then Rotate or Flip, then Flip Horizontal.

8. You are done! Just print it out and cut it out!

Alphabet Stamps

Finally, my new found love, alphabet stamping. I find myself using alphabet stamps more and more in my craft projects and coordinating them with hand lettering. This prompted me to add a section on alphabet stamping to the end of this book.

One can never have enough alphabets to choose from when working on craft projects. As I began acquiring my alphabet stamps, I realized they took up a great deal of space because of the wood blocks. I was accustomed to carrying around all of my alphabets in a binder.

Un-mounted sheets of rubber alphabets are less expensive, but storing the little pieces is a nightmare. I also like to stamp the old fashioned traditional way with a cushion and wood mount.

This inspired me to develop my own patent-pending alphabet stamping system—Performance Art Stamps™.

I have converted several alphabets in this book into alphabet stamps. These alphabet stamps are cushioned and magnet backed.

What is new and exciting about these stamps is that up to 15 alphabet stamp sets can be stored in a binder. The alphabet stamps, which are magnet backed, readily adhere to the thin metal plates that are kept in the binder.

This creates easy and secure storage of the stamps. To use the alphabet stamps, I have created several sizes of wood mounts that come with a metal plate on the bottom of the wood mount.

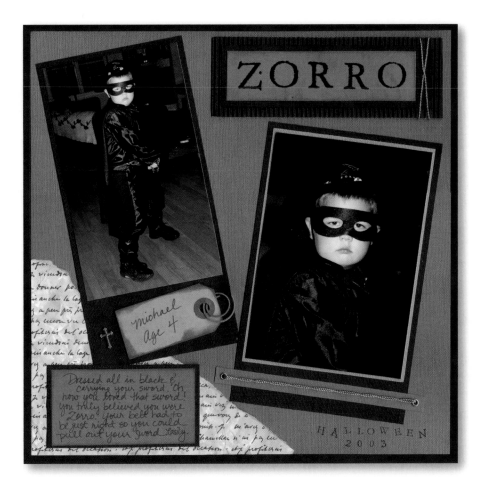

Zorro
by Debra Beagle

TITLE ALPHABET: Grace, Performance Art Stamps

PENS: Marvy Medallion .03, black. Marvy Memories Le Plume, fine point, burnt umber

OTHER SUPPLEIS: Paper by Bazzill Basics. Corrugated paper by DMD. Clip and charm by Making Memories. Gold fibers from ProvoCraft. Suze Weinberg's Ultra Thick Embossing Powder by Ranger Industries. Brown hybrid ink by Superior. Adhesive by Glue Dots.

Create Your Own Destiny Card

by Holle Wiktorek

TITLE ALPHABET: Grace, Performance Art Stamps

Whenever you need a stamp you just peel it off the metal storage plate in the binder and the magnet backed stamp adheres to the bottom of the wood mount.

You can lay out several letters on the wood mount to create a word and get the correct positioning of the entire word before you stamp. I have also provided each alphabet stamp set with extra commonly used letters. So not only can you stamp words but you can also create personalized sayings to use on your projects. This saves a great deal of time, versus stamping each individual letter. An important thing to remember when creating personalized stamped words or sayings is that you must spell words backwards on the wood mount because you will be flipping the image over to stamp it.

Prettiest Pumpkin in the Pumpkin Patch

by Victoria Bowling

TITLE ALPHABET: Grace, Performance Art Stamps; Lourdes #27

PEN: Marvy Artist, black

OTHER SUPPLIES: Tag by 7Gypsies. Ink by StazOn, orange and green.

DESIGNER NOTES: I inked the twill tape with orange StazOn ink and then stamped the words on the twill tape using green StazOn ink.

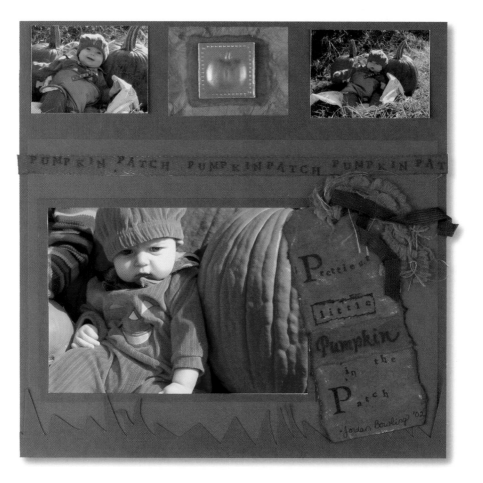

With this system you have the ability to personalize projects and still stamp following a traditional stamping method with wood mount, cushion and rubber. Furthermore, you gain the ease of storing numerous alphabet stamps in a binder, and only have to store a few wood blocks.

Combining Alphabet Stamping with Hand Lettering

Here are some ideas for how you can incorporate alphabet stamping into your hand lettering projects.

❑ You can interchange upper and lower alphabets, or different alphabet stamps, to create words.

❑ Use brush markers to color the individual letters in different colors. Use one color to color the top of the letter and a different color to color in the bottom of the letter.

❑ Only use the alphabet stamps to create the most important word in the title.

❑ Ink an alphabet stamp and stamp once, and then stamp again without re-inking for a shadow effect.

❑ Stamp letters on page with Versamark ink and then apply embossing powder and heat set for an embossed look.

❑ If stamping on vellum, lay graph paper underneath so you have guidelines for positioning your stamps.

❑ Stamp letters on metal using Stazon ink and heat set.

❑ Use alphabet letters for other objects. Example: use V's for grass, birds or sun rays.

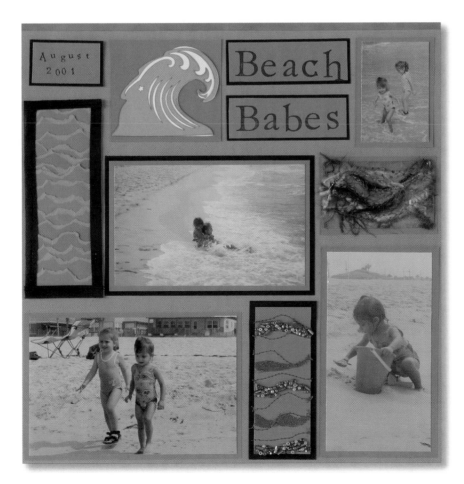

Beach Babes
by Victoria Bowling

TITLE ALPHABET: Grace, Performance Art Stamps

INK: Marvy Matchables, black.

OTHER SUPPLIES: Paper by Bazzill Basics. Adhesives by Glue Dots.

DESIGNER NOTES: Using the Performance Art Stamps helped save time on this layout. Ordinarily, I would have stamped each letter individually. Instead, I was able to lay out the entire title on my wood mount and stamp everything at once.

Thank You!

Holle Wiktorek contributed many of these alphabet stamping ideas.

❑ For an aged look, crumple paper and then unfold and flatten. Stamp on the paper. The letters will look distorted.

❑ Use the alphabet stamps to create an alphabet around the page for an alphabet soup or school theme.

❑ Interchange alphabet stamps with stickers to create a "ransom letter" effect.

❑ Stamp individual letters on separate small tags and then put the tags in a row to create a title.

❑ Using Stazon ink, ink a piece of ribbon or twill tape. Let it dry. Then stamp on the ribbon or twill tape, using another color of Stazon ink and stamping with small alphabet letters to create words or sayings of your choice. Adhere ribbon or binding tape to project using Xyron or brads (see layout on page 88).

❑ Stamp a capital letter at the beginning of your journaling to bring attention to it or emphasize it.

Florida 2002
by Victoria Bowling

TITLE ALPHABET: Grace, Performance Art Stamps

PENS: Marvy Memories Artist, black and grey

OTHER SUPPLIES: Marvy Matchables black ink. Beach transparency.

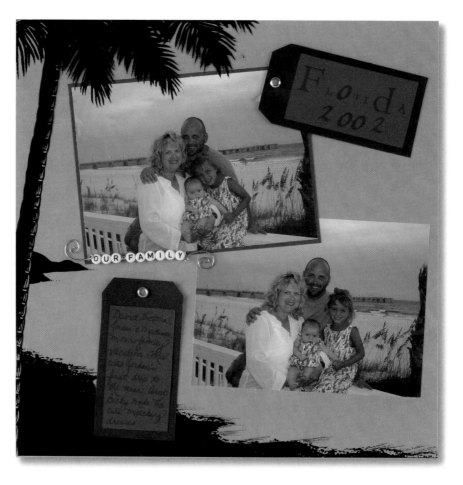

Built for Speed

The Performance Art Stamp System makes it easy to store and use alphabet stamps. Magnetic backings on the letters make them stick to the metal plates in the binder and the metal backing on the wood mounts.

set your pen

trace

trace

trace

trace

copy

set your pen

trace

copy

trace

copy

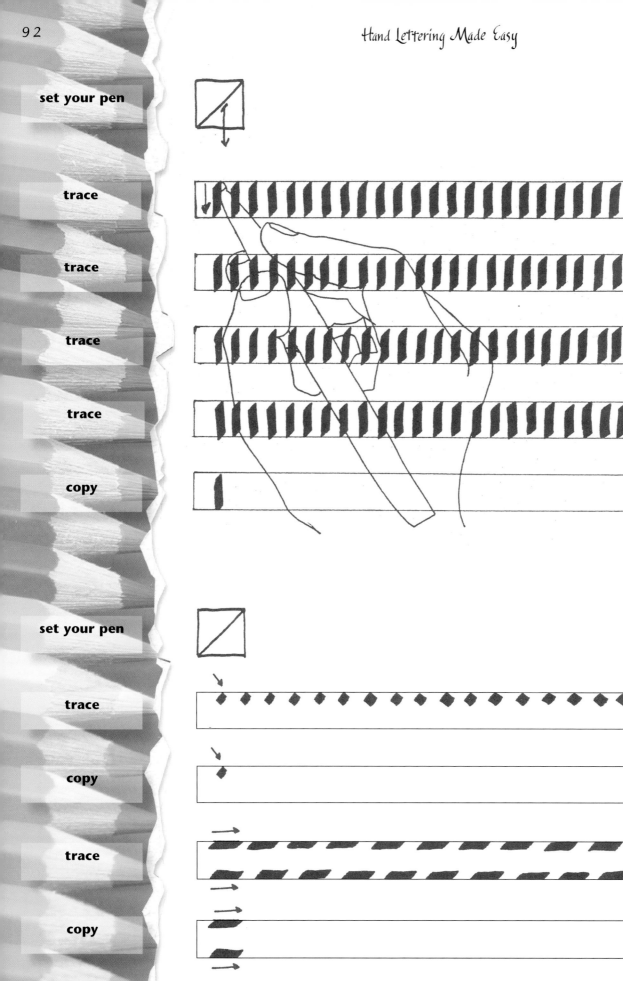

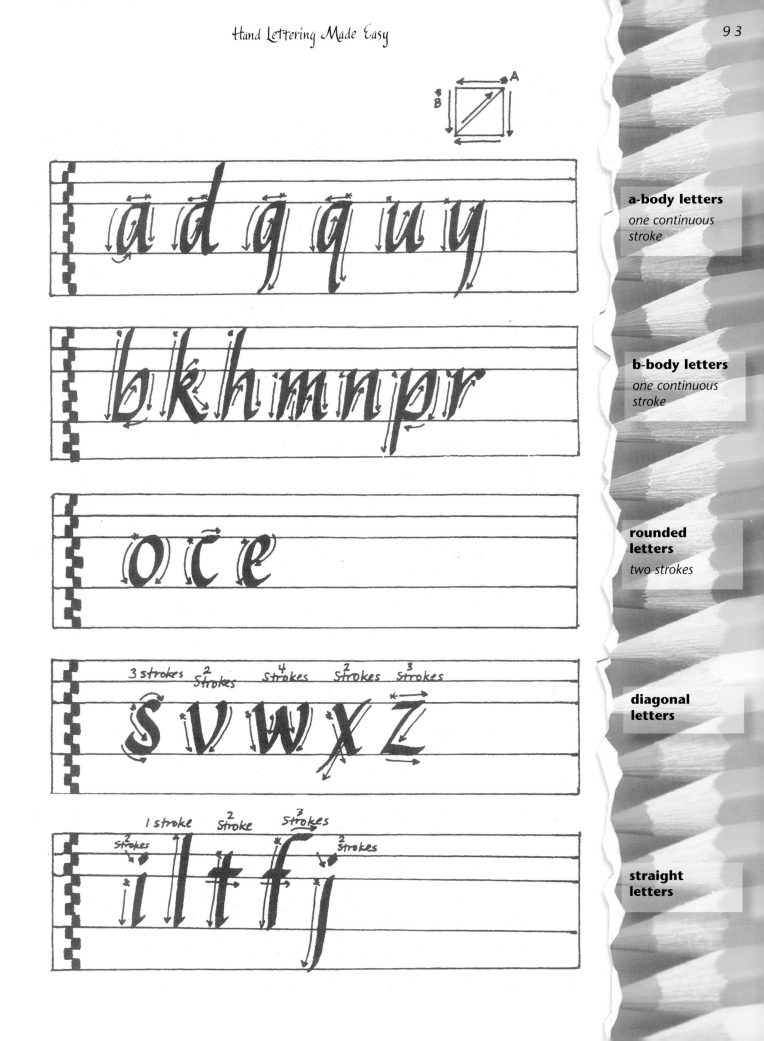

a-body letters
one continuous stroke

b-body letters
one continuous stroke

rounded letters
two strokes

diagonal letters

straight letters

Friendly Faces

The alphabets in this book were given special names of women, many of them Spanish names. They were inspired by the women who contributed to this book. Contributors' photographs, names and page numbers appear to the right.

Victoria Bowling
pages 26, 39, 41, 49,
55, 58, 70, 72, 88-90,
96

Karen Moffatt
pages 19, 53, 56,
60, 62

Kate Childers
pages 4, 60, 66, 68,
72

Wendy Pannell
pages 18, 27, 29, 31,
48-49, 57, 61, 69

Christy Kalbhin
page 6, 28-29, 50-51,
61, 63, 65, 83

Laurie Waldron
page 56

Patricia League
pages 7, 27, 54, 63-64,
68

Nancy Walker
pages 5, 52, 54, 59, 64,
67, 71, 73

Bonnie Lees
page 28, 37

Holle Wiktorek
pages 2, 18-19, 57, 66,
69, 88

Donna Luncford
page 26-27, 51, 65,
78

Also Contributing:
Linda Beagle page 79
Gail Golliher page 22
Pamela Lange pages 22-23
Marilla Naron pages 29, 63, 69

Kelly Milligan
62

Alphabet Index

Alphabets in Action

Use this index to find the individual alphabets used in examples throughout the book. The alphabets appear at the back of the book in order of number.

Marvy Pens at Uchida.com

To learn more about the Marvy products featured in this book, visit your local scrapbook or craft store or visit Marvy online at www.uchida.com.

Time flies when you're hand lettering and alphabet stamping! Stay in touch and see new products and events by visiting me online at www.debrabeagle.com.

Tag designed by Victoria Bowling.

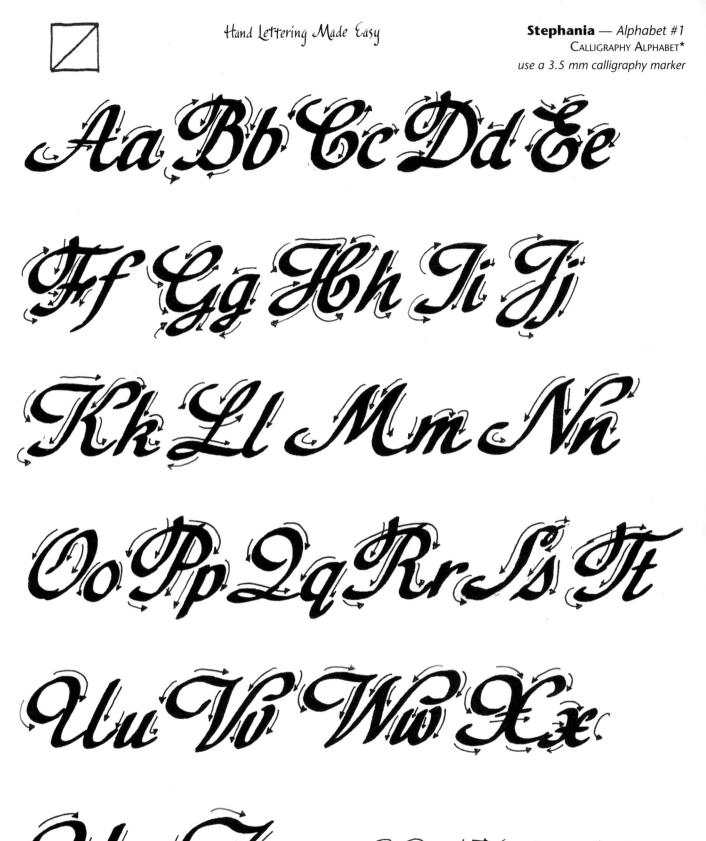

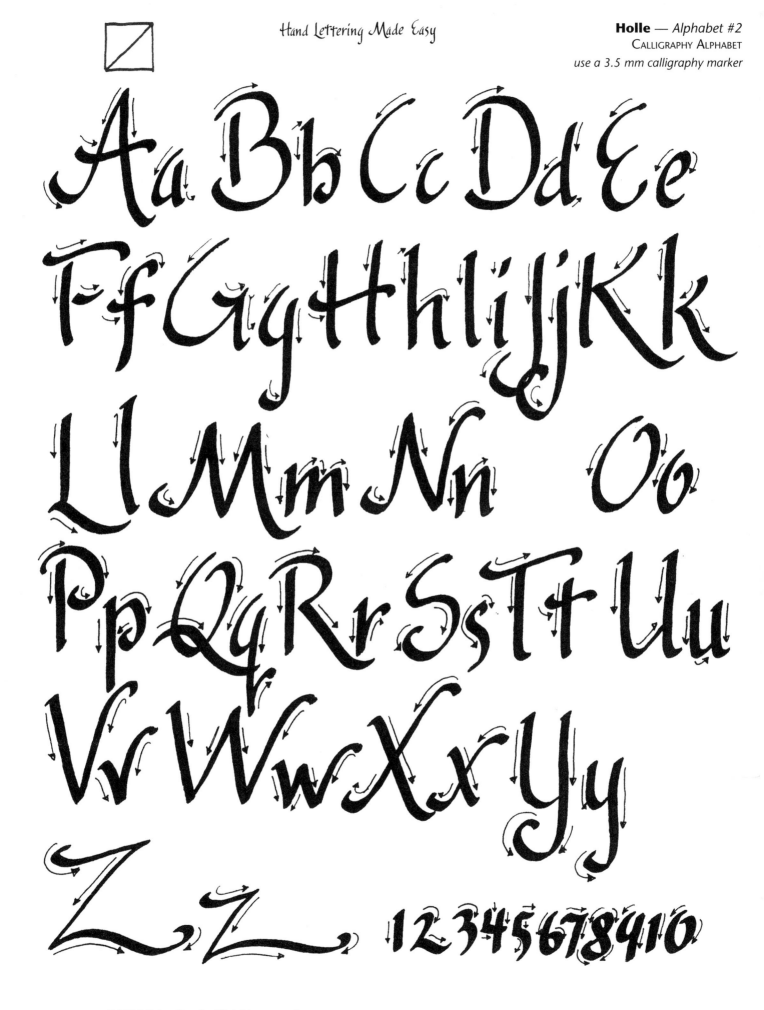

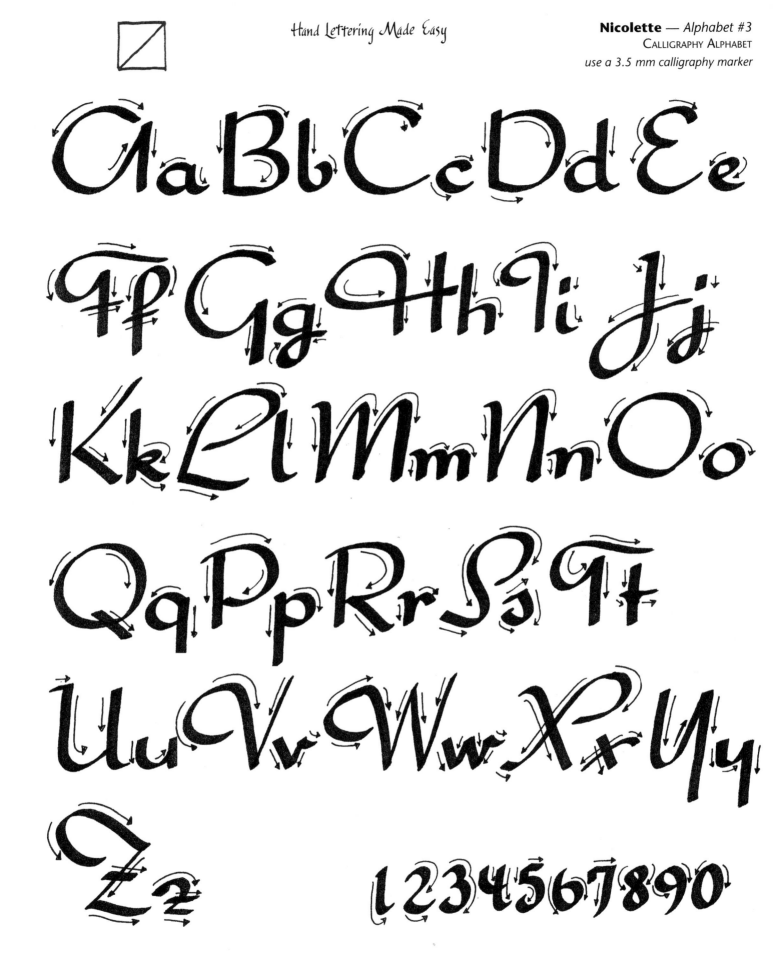

Aa Bb Cc Dd Ee Ff

Gg Hh Ii Jj Kk Ll

Mm Nn Oo Pp Qq

Rr Ss Tt Uu Vv Ww

Xx Yy Zz

1234567890

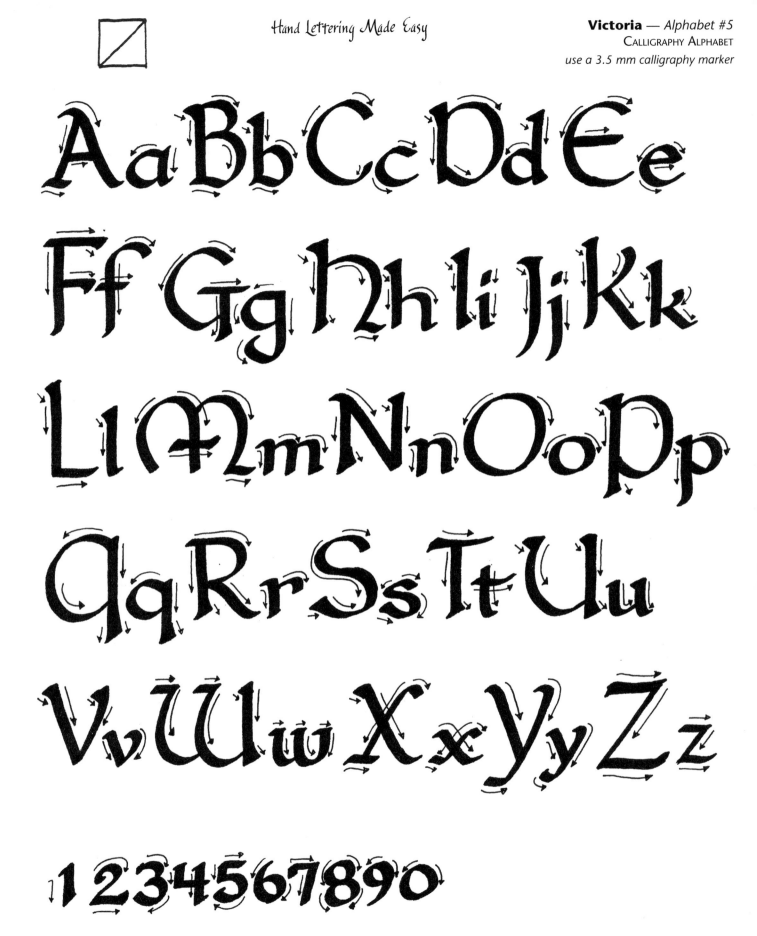

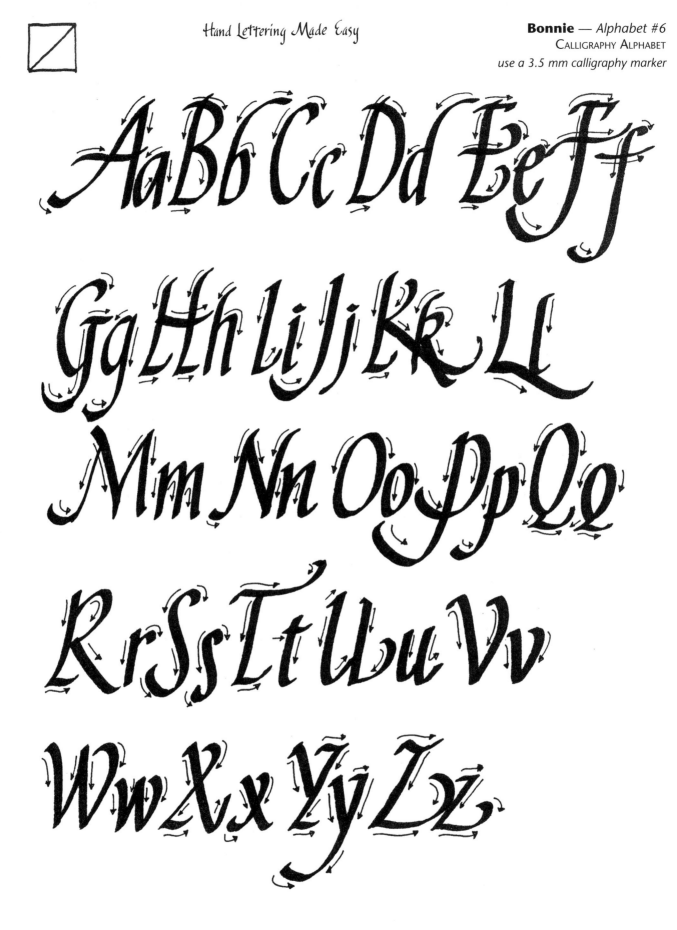

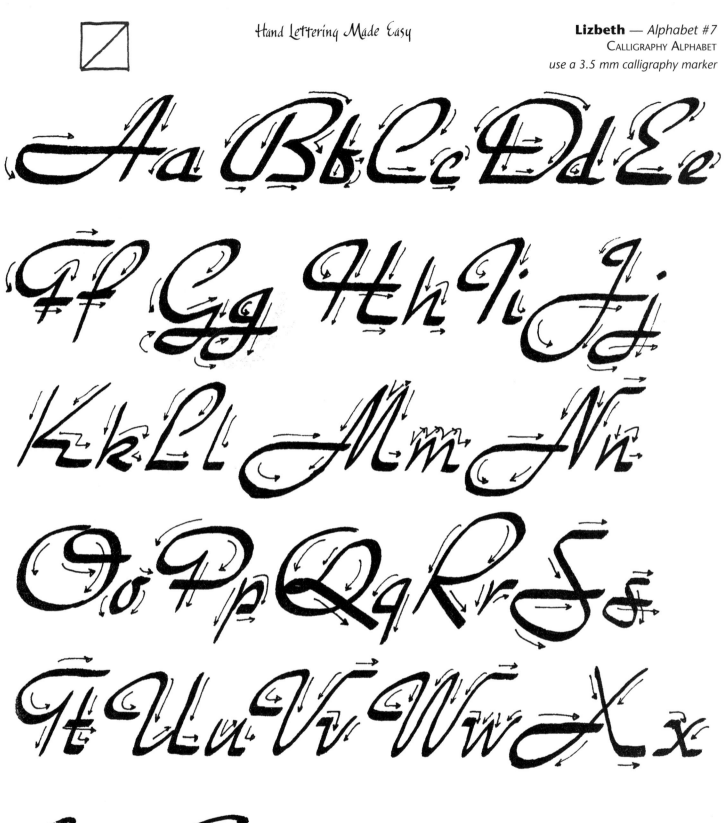

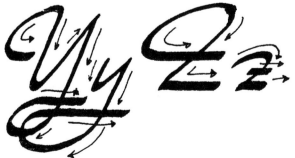

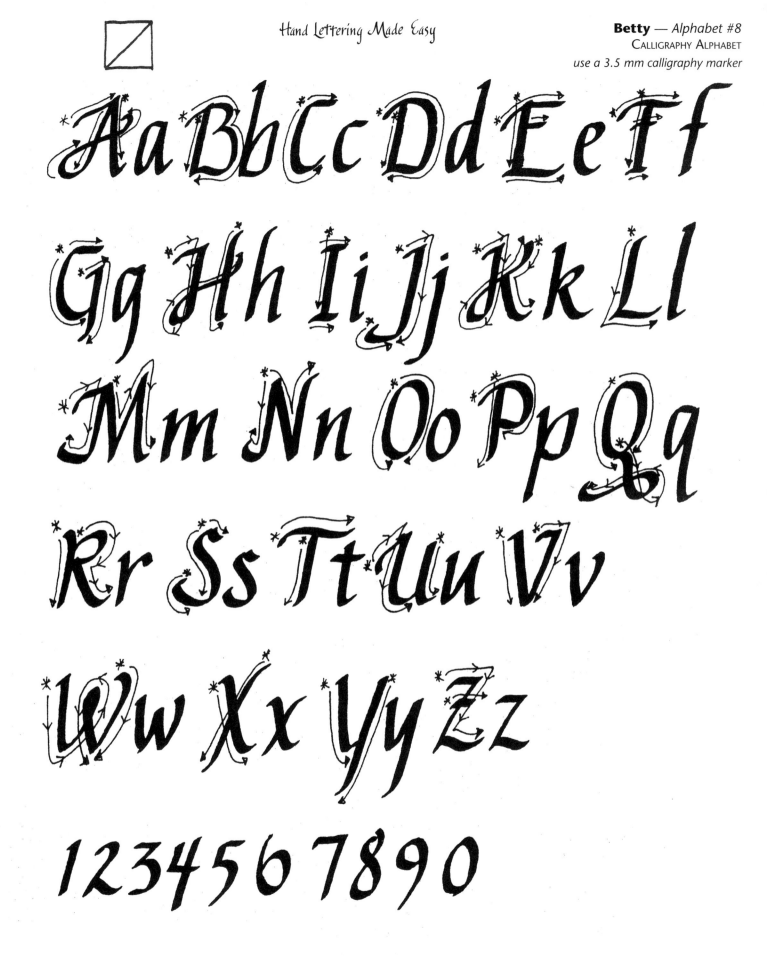

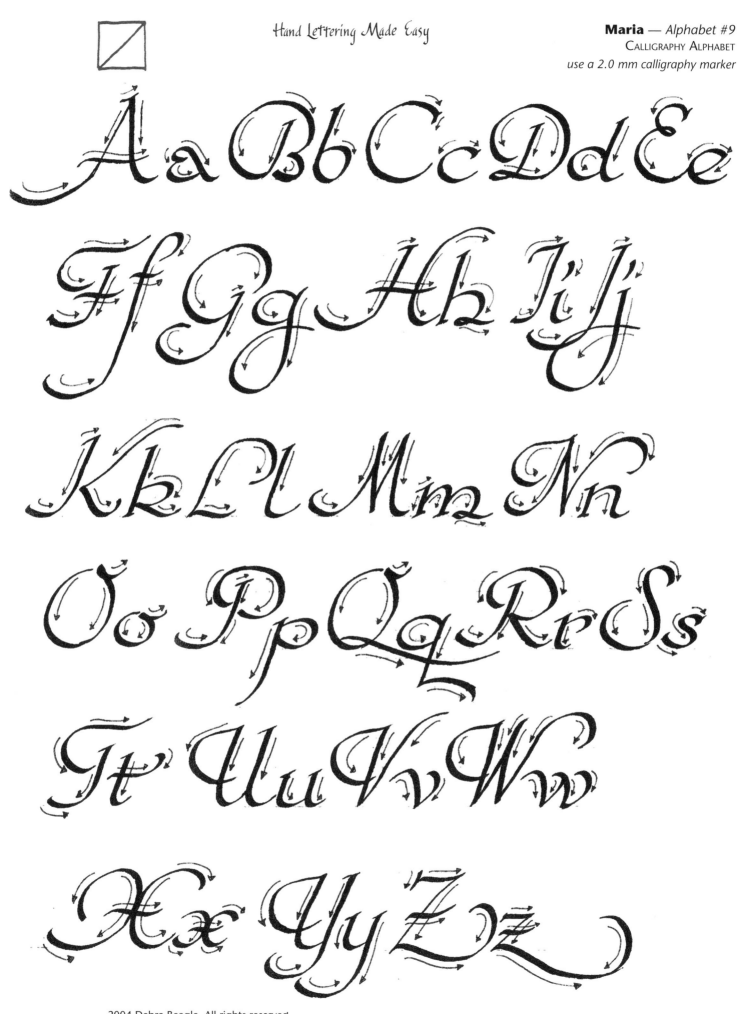

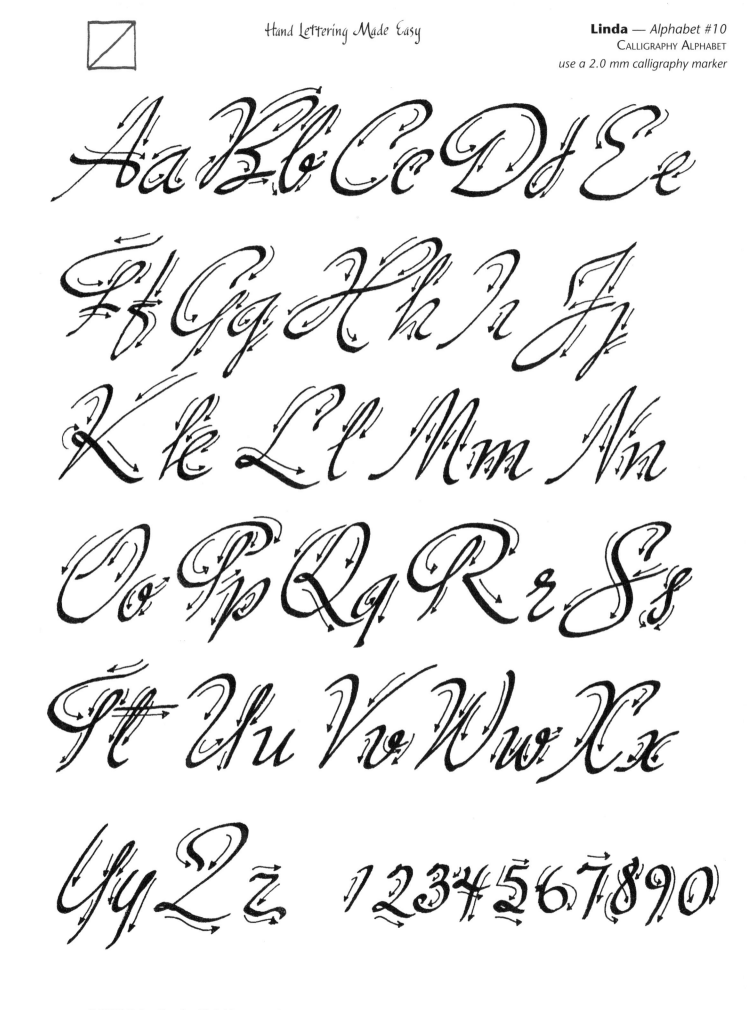

Aa Bb Cc Dd Ee Ff

Gg Hh Ii Jj Kk

Ll Mm Nn Oo Pp Qq

Rr Ss Tt Uu Vv

Xx Yy Zz

1 2 3 4 5 6 7 8 9 0

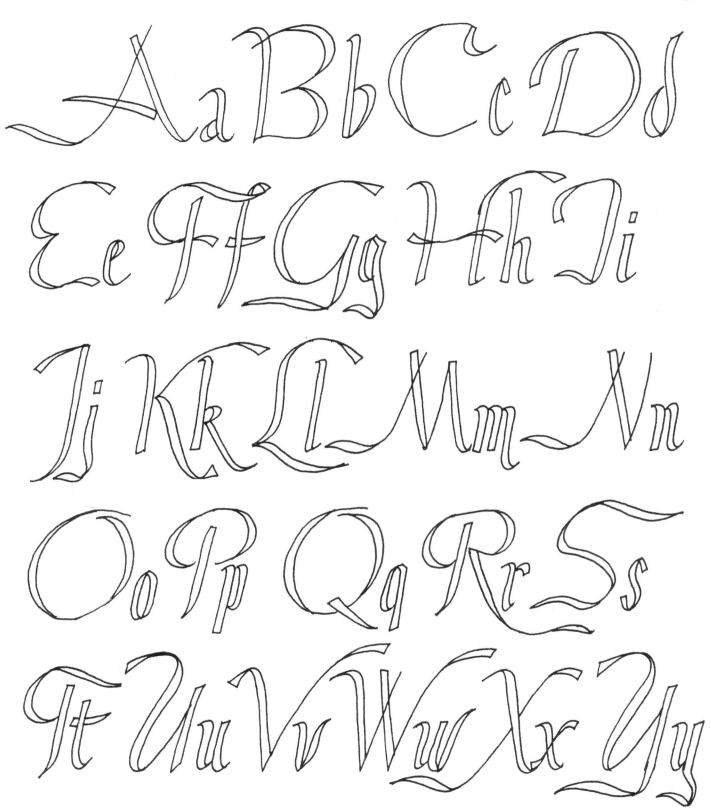

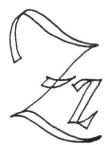

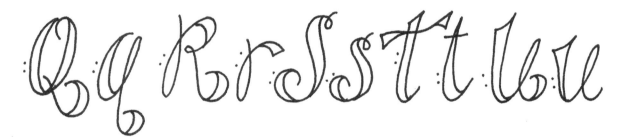

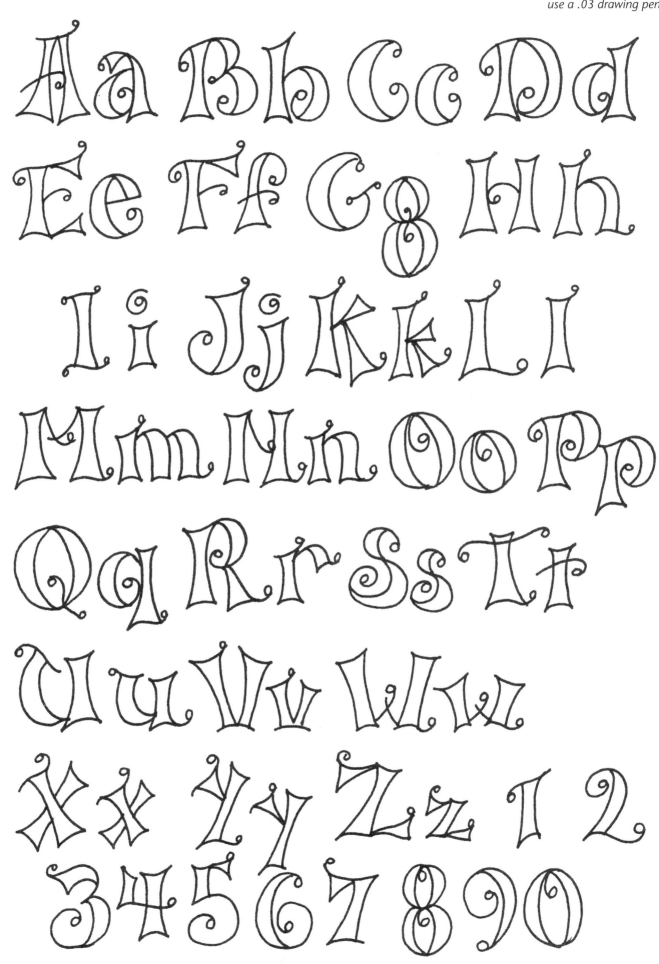



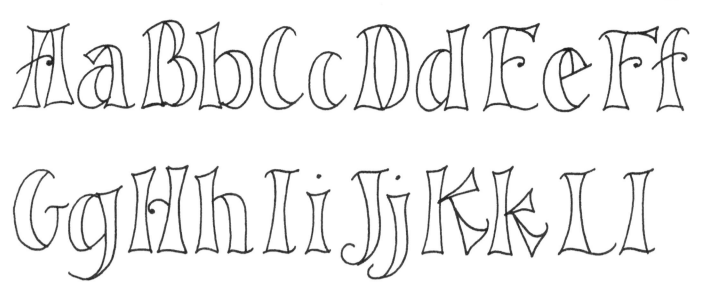

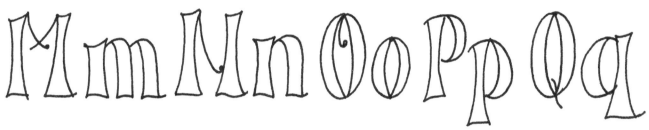

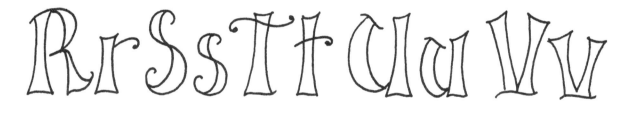

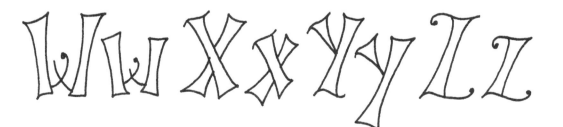

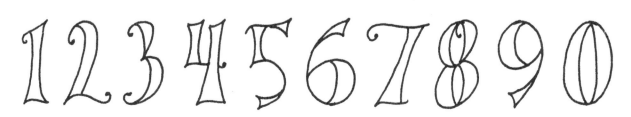

Aa Bb Cc Dd Ee

Ff Gg Hh Ii Jj

Kk Ll Mm Nn

Oo Pp Qq Rr Ss

Tt Uu Vv Ww

Xx Yy Zz

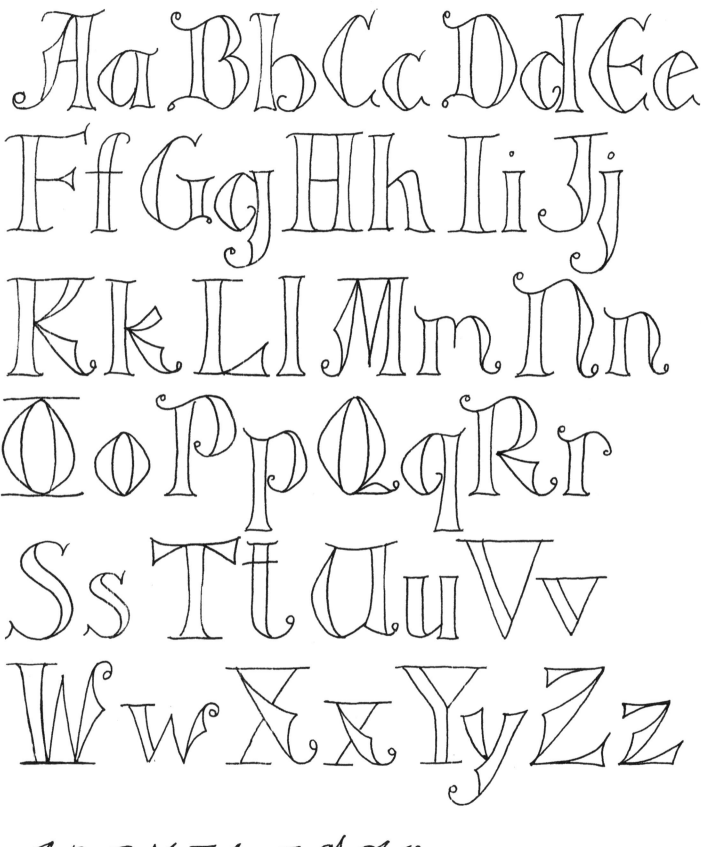

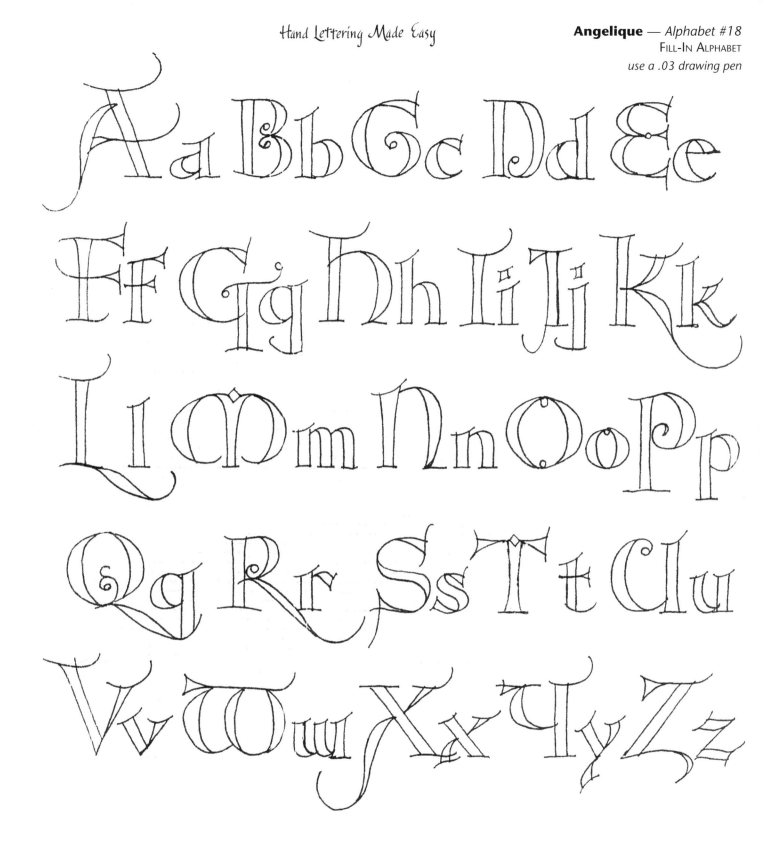

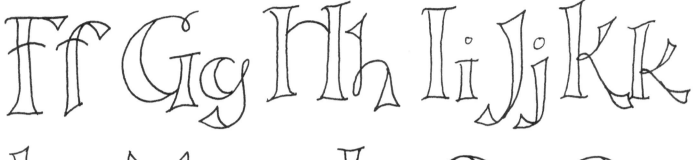

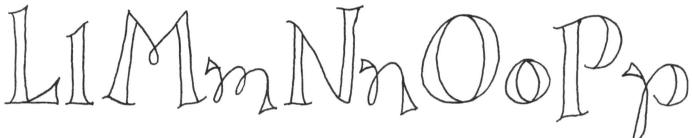

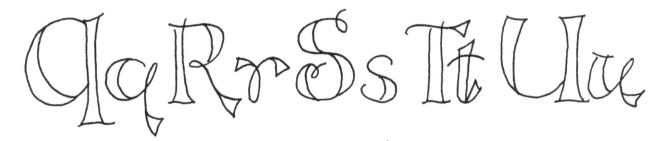

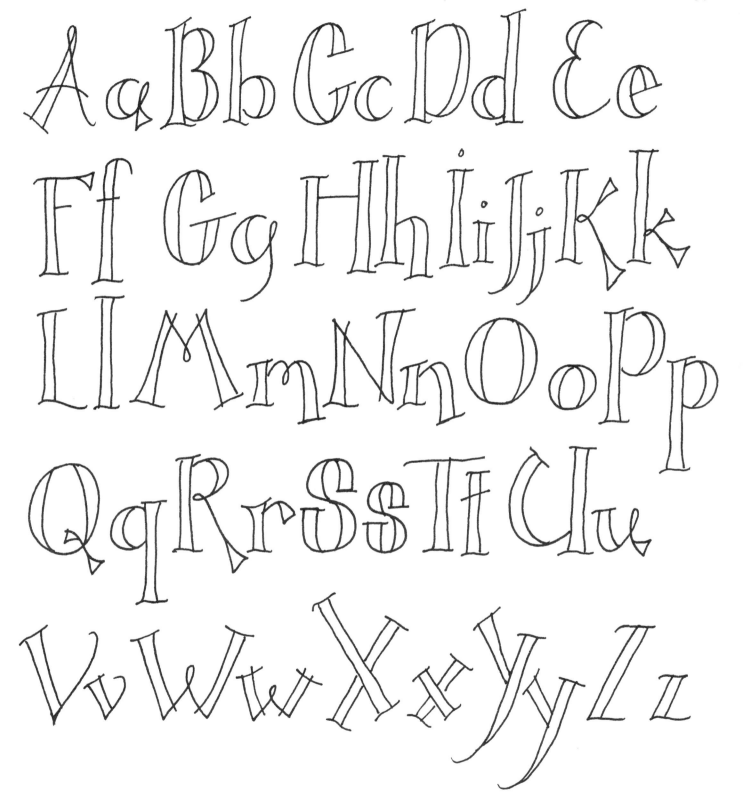

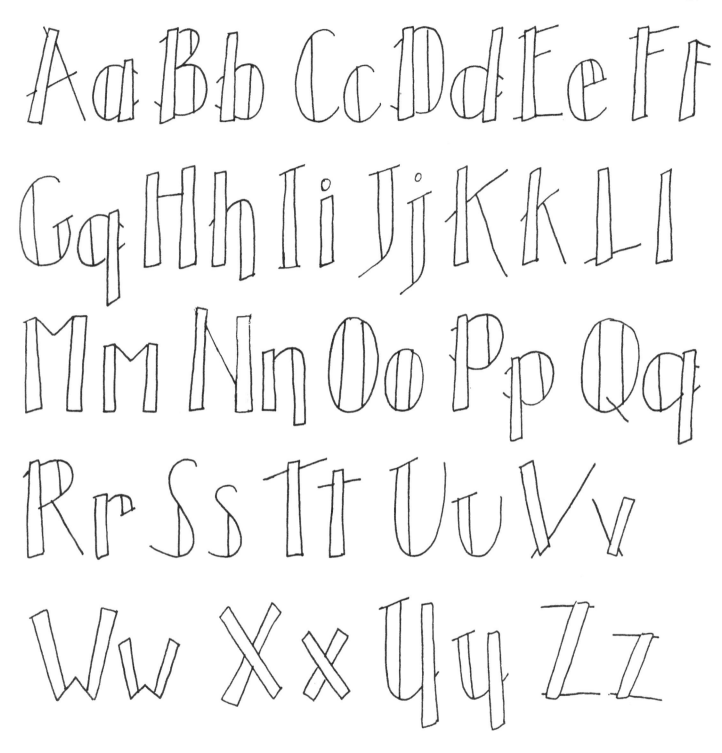

Aa Bb Cc Dd Ee
Ff Gg Hh Ii Jj
Kk Ll Mm Nn
Oo Pp Qq Rr Ss
Tt Uu Vv Ww
Xx Yy Zz

1234567890

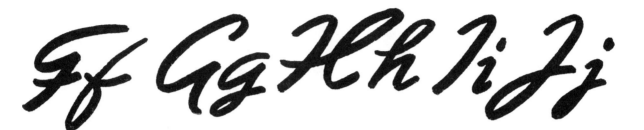

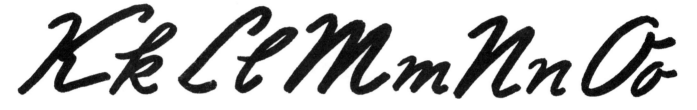

Aa Bb Cc Dd Ee Ff

Gg Hh Ii Jj Kk

Ll Mm Nn Oo Pp

Qq Rr Ss Tt Uu

Vv Ww Xx Yy Zz

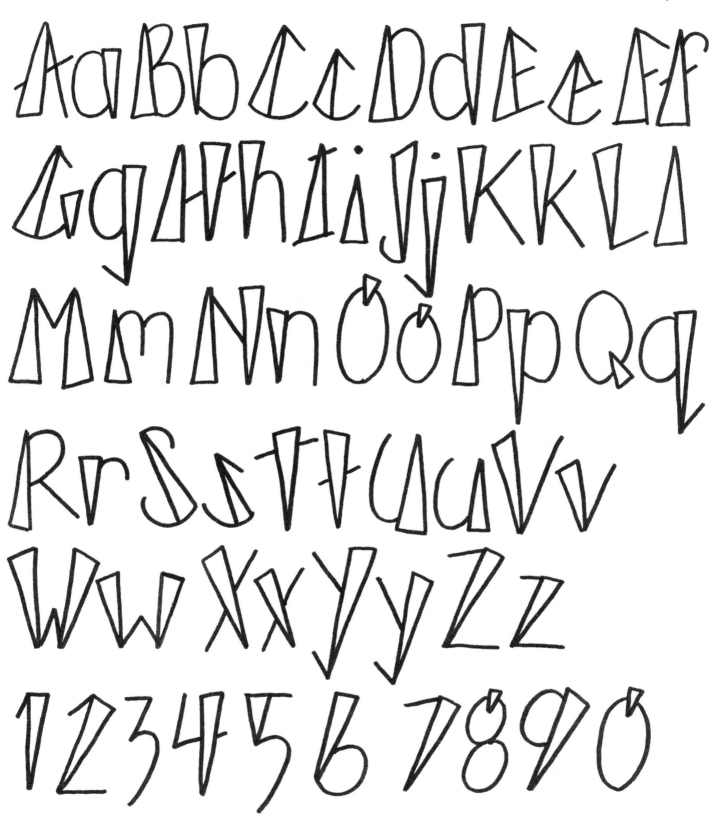

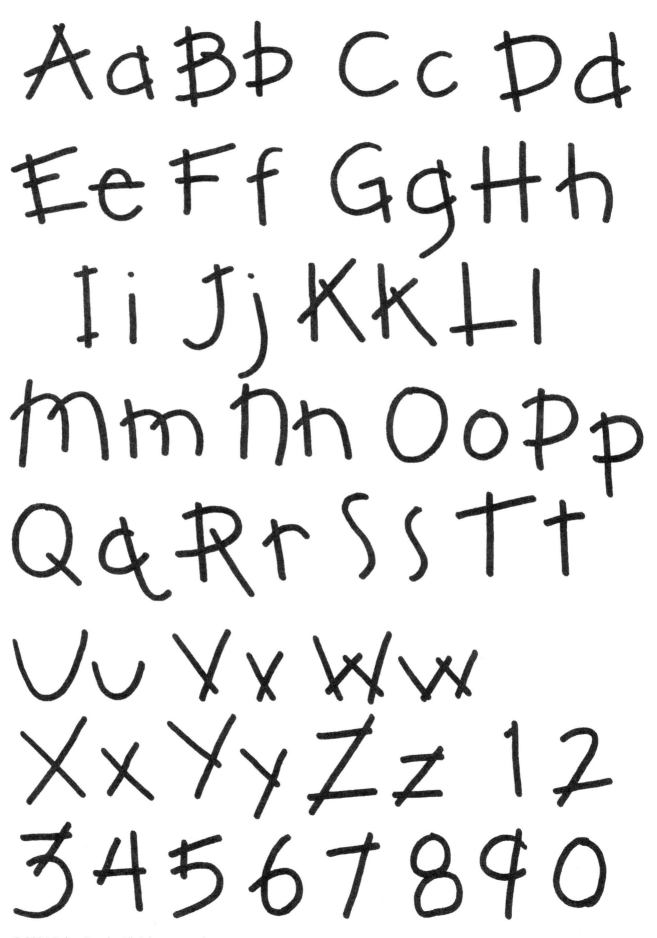

Aa Bb Cc Dd Ee Ff

Gg Hh Ii Jj Kk Ll

Mm Nn Oo Pp Qq

Rr Ss Tt Uu Vv

Ww Xx Yy Zz

1234567890

Aa Bb Cc Dd Ee Ff

Gg Hh Ii Jj Kk Ll

Mm Nn Oo Pp Qq Rr

Ss Tt Uu Vv Ww Xx

Yy Zz

Aa Bb Cc Dd Ee

Ff Gg Hh Ii Jj Kk

Ll Mm Nn Oo Pp

Qq Rr Ss Tt Uu

Vv Ww Xx Yy Zz

1 2 3 4 5 6 7 8 9 0

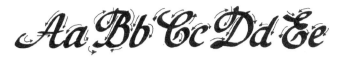

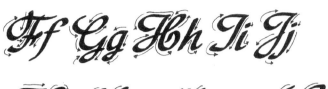

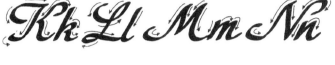

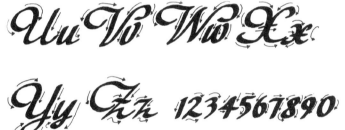

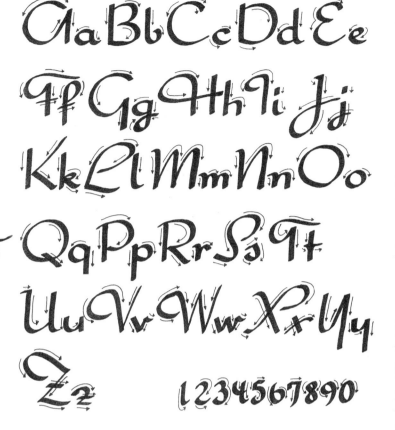

Aa Bb Cc Dd Ee Ff
Gg Hh Ii Jj Kk Ll
Mm Nn Oo Pp Qq
Rr Ss Tt Uu Vv
Ww Xx Yy Zz
1 2 3 4 5 6 7 8 9 0

Aa Bb Cc Dd Ee Ff
Gg Hh Ii Jj Kk
Ll Mm Nn Oo Pp
Qg Rr Ss Tt Uu
Vv Ww Xx Yy Zz

Aa Bb Cc Dd
Ee Ff Gg Hh
Ii Jj Kk Ll
Mm Nn Oo Pp
Qg Rr Ss Tt
Uu Vv Ww
Xx Yy Zz 1 2
3 4 5 6 7 8 9 0

Aa Bb Cc Dd Ee
Ff Gg Hh Ii Jj Kk
Ll Mm Nn Oo Pp
Qg Rr Ss Tt Uu
Vv Ww Xx Yy Zz

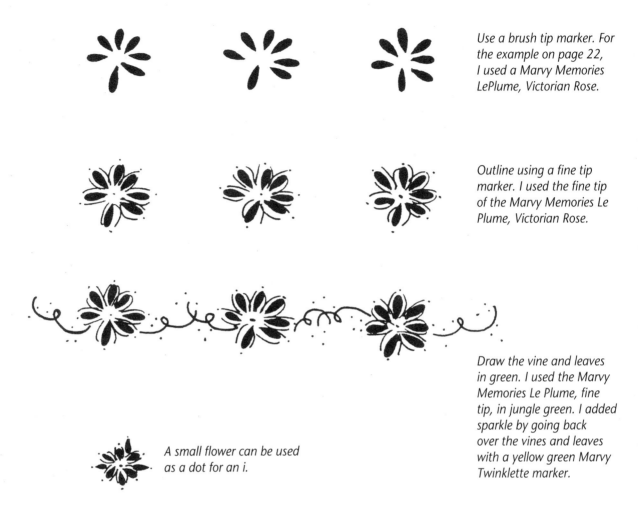

Use a brush tip marker. For the example on page 22, I used a Marvy Memories LePlume, Victorian Rose.

Outline using a fine tip marker. I used the fine tip of the Marvy Memories Le Plume, Victorian Rose.

Draw the vine and leaves in green. I used the Marvy Memories Le Plume, fine tip, in jungle green. I added sparkle by going back over the vines and leaves with a yellow green Marvy Twinklette marker.

A small flower can be used as a dot for an i.

Use a calligraphy marker with a 3.5 mm nib to trace the lettering "Wedding Day." I used Marvy Memories Calligraphy, wisteria.

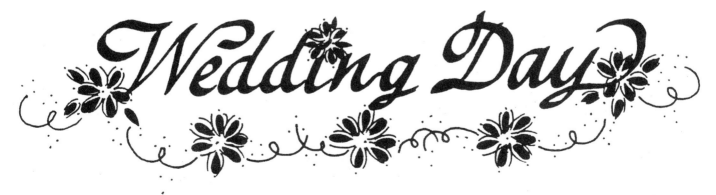

Hand Lettering Made Easy

Tradition

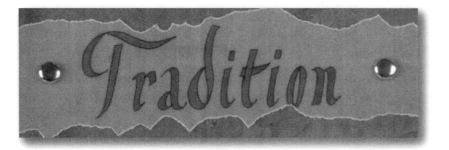

create

Dream

Pretty Baby

thank you

Wedding

Happy Father's Day

bee happy